HOCKEY IN ROCHESTER
THE AMERICANS' TRADITION

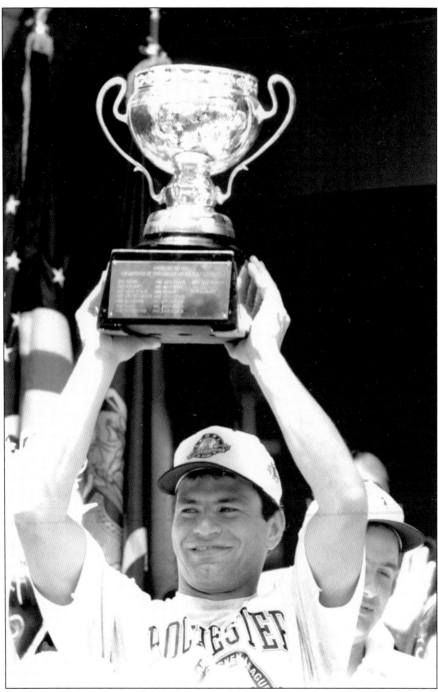

Mr. Amerk. Jody Gage hoists the American Hockey League's (AHL) holy grail, the Calder Cup, at the championship festivities in front of the Rochester City Hall following the Amerks' sixth Calder Cup championship, in 1996. Gage, who became the club's general manager that year, retired during the regular season as the third leading scorer in AHL history. He was later honored with the retirement of his No. 9 jersey and was inducted into the Rochester Americans Hall of Fame in 1999. (Rochester Americans.)

HOCKEY IN ROCHESTER
THE AMERICANS' TRADITION

Blaise M. Lamphier

Copyright © 2004 by Blaise M. Lamphier
ISBN 978-0-7385-3694-1

Published by Arcadia Publishing
Charleston, South Carolina

Printed in the United States of America

Library of Congress Catalog Card Number: 2004110644

For all general information contact Arcadia Publishing at:
Telephone 843-853-2070
Fax 843-853-0044
E-mail sales@arcadiapublishing.com
For customer service and orders:
Toll-Free 1-888-313-2665

Visit us on the Internet at www.arcadiapublishing.com

The photograph on the back cover shows a 1984 game at the War Memorial between the Amerks and the Adirondack Red Wings. Note current coach Randy Cunneyworth as an Amerk and "Mr. Amerk" Jody Gage as a Red Wing. The photograph is entitled *No Goal* and is copyrighted by Joe Territo.

For Allie, Mom and Dad, Joanne, and the girls.

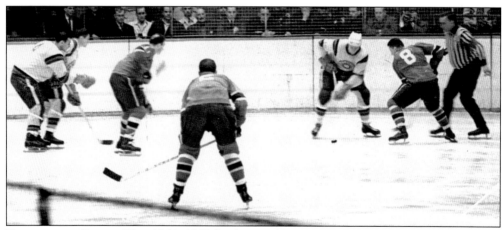

PRELUDE TO GLORY. This 1964–1965 Rochester Americans game against the Quebec Aces was played at the Rochester Community War Memorial. Rochester players, in their starred red uniforms, from left to right, are Les Duff, Don Cherry, and Wally Boyer. Rochester steamrolled both Quebec and the longtime rival Hershey Bears by 4-1 game margins to capture the first franchise Calder Cup before 7,556 ecstatic fans on April 30, 1965. Amerk team captain Larry Hillman stated after the final that he had played on "a few Stanley Cup winning teams, and I honestly can say I never heard anything like this before. This was the greatest ovation I have ever heard given a hockey club, and it really made me and the rest of the boys feel even greater than we already did knowing we were the champs." (Rochester Americans.)

Contents

Acknowledgments — 6

Introduction: A Heritage on Ice — 7

1. O, Say Can You See — 9
2. The Dawn's Early Light — 21
3. So Proudly We Hailed — 47
4. Broad Stripes — 63
5. Bright Stars — 77
6. The Perilous Fight — 111
7. Rockets' Red Glare — 123

ACKNOWLEDGMENTS

This is my opportunity to "light the lamp" and tap a blade against the boards for all those who have been on the front line assisting me throughout the evolution of this pioneer project. A hockey team can only succeed with great bench strength, and my team on this book has been magnificent, particularly in the clutch.

I would like to thank Tiffany Howe, publisher at Arcadia Publishing, for believing in the importance of the realization of this project. I am eternally grateful to the Rochester Americans, particularly Craig Rybczynski, director of communications, who opened the team's archives to help crystallize my vision of a lasting photographic tribute to one of the most successful and respected organizations in professional sports. Both have exercised the proverbial patience of Job in the face of my tireless inquiries.

I would also like to recognize specifically Jody Gage, general manager of the Americans, for his ongoing commitment to preserve the Amerks' history and his belief in this endeavor; Ruth Rosenberg-Naparsteck, Rochester city historian, for her ongoing support; Scott Pitoniak of the *Democrat & Chronicle*, a fellow author and vintage baseball player, for the animated discussions that led to my pursuit of this goal; and Priscilla Astifan, also a fellow author and noted sports researcher, who has encouraged the development of this volume from its inception.

I am particularly thankful for the support of Ernie Fitzsimmons, president of the Society for International Hockey Research; Ira Srole and David Mohney of the City of Rochester's photograph lab; volunteer Tim O'Connell and the entire staff of the Rochester Public Library's Local History Division and Retrieval Services Division; Paula V. Smith of the Rochester Public Library; Jeff Calkins of the Blue Cross Arena at the War Memorial; Tyler Wolosewich of the Hockey Hall of Fame in Toronto; Joe Giordano and Greg Warren of the ESL Sports Centre; Joe Territo of Territo Photography; Kevin Oklobzija of the *Democrat & Chronicle*, and all of my friends in Section 109, especially John and Anne DiProsa, who believed in this from the beginning; every photographer, known and unknown, who has preserved Rochester's hockey history for the last 100 years; and for the late Gerard Russo, whose dedication as a boy to keeping scrapbooks during the Amerks' early years helped inspire me to complete this project.

Finally, I thank my wife, Allie, and the girls, whose love and support has never failed me; my mom and dad, Anne and Frank Lamphier, who shared his love of this great game that extends for him back to the AHL's Providence Reds of the 1940s; and my grandfather, Salvatore DeMaria, who was an immigrant to Rochester in 1905 and who taught me to honor the red, white, and blue of the flag of this great nation, something the Rochester hockey team and community have done from game one in 1956.

INTRODUCTION
A Heritage on Ice

I still recall with great awe my first visit to the War Memorial in 2000 as if I were visiting a cathedral of gothic import. I gazed at the blazing red banners of six Calder Cup championship teams and countless other division titles that adorned the rafters of the building and tried to imagine what it was like to watch the legendary Billy Reay coach those first members of the new AHL franchise Rochester Americans in the inaugural 1956–1957 season. I wondered how he was able to deal with the divergent philosophies and mindsets of the brass and player personnel from his joint affiliates of the NHL's greatest rivals: the Montreal Canadiens and the Toronto Maple Leafs. Sportswriter Hans Tanner documented Reay's challenges of handling two distinct groups of players who had, in some cases, been regional rivals from the time they first laced up skates and were inherently polarized in their behavior and attitudes. Nevertheless, Reay, after the team's disturbing 0-5-2 start, was able to galvanize the team of star-spangled initiates into a club that upended the defending AHL champions and their MVP goalie, future Hall of Famer Johnny Bower, by taking four of five games in the first round of the playoffs.

Although they did not capture the Calder Cup that first season, Reay's charges set a standard for excellence for the fledgling franchise. The Rochester Americans, in addition to their six Calder Cups, have reached the finals a remarkable average of once every three seasons—16 times in 48 campaigns—and are second only to the Hershey Bears in total Calder Cup championships among active franchises (the original Cleveland Barons won nine, while Hershey has captured eight in 66 seasons). Through the years, Rochester has witnessed great players who began their professional careers here, such as Hockey Hall of Famer and Rochester Americans Hall of Famer Gerry Cheevers; others who arrived here after or in the waning moments of celebrated NHL careers, such as Yvon Lambert and Hockey Hall of Famer Grant Fuhr; and still others who achieved and honed their greatness at the AHL level here in Rochester, such as Rochester Americans Hall of Famers Jody Gage and Bobby Perreault. After moving to Rochester in 2001, I began to realize that this history was not adequately preserved in book form, and hence I set out to chronicle the history in photographs.

Nearly 50 years of a celebrated team's history was daunting enough to fit in a 128-page book, but I was determined to add Rochester's earlier hockey history to the story as well in an attempt to find out just how Rochester came to be a hockey town. Longtime fans insisted that it had always been a hockey town, and I became fascinated by how little was recorded on the period prior to the Americans' arrival. In fact, a 10-part history of Rochester sports published in one of the local papers in the early 1950s devoted just one brief paragraph to Rochester's hockey heritage. The entry referred to Rochester's brief experiment with professional hockey

in the 1930s and that it had failed; however, the account was erroneous or misleading on three points: that the professional team had played for three years at an outdoor rink; that the rink was located where the Red Wings played baseball; and that the team failed because the city council would not build a larger arena. Through my research, I was able to establish that the professional team, the Rochester Cardinals, played just one season here in the old International Hockey League; that they played in Rochester's first all-enclosed indoor rink at Building No. 5 at Edgerton Park, which the club's principals dubbed Edgerton Park Arena; and finally, that while a larger rink might have kept a professional hockey team here, the primary reason Rochester lost a franchise in 1936 was the merger of the IHL with the Can-Am League to form the nucleus of what became the AHL. I came to the realization that if, in the early 1950s, the view of the history of hockey in Rochester was that distorted to a respected sports staff, I needed to commit myself to setting the record straight, and it would require substantial research.

In any event, this volume is the result of that commitment. I have tried to balance hockey's earliest beginnings amongst amateurs here a century ago while shedding light on the Cardinals' club of the 1930s—an affiliate of the NHL's defunct New York Americans, also known as the Amercs or Amerks—and spending the bulk of my research on the organization we are very lucky to have here in Rochester, the Rochester Americans. These players have skated, scratched, and clawed their way to greatness in our lifetimes, a true jewel of not just hockey but the world of professional sports in our backyard on the same rink for almost half a century—a franchise that boasts over 150 alumni who have played over 300 games in their NHL careers. I seek your forgiveness for those players who may have been omitted from this collection, but in covering a period this vast with so many heroes, I was bound to make difficult choices in that regard or to let the project remain forever ongoing. If what is here memorializes the achievements of those who have made history here and serves as a prelude to a golden year of celebration, I have more than achieved my objective. If I spark a few special memories along the way of your visits to the War Memorial, then I have done what I set out to do.

—Blaise M. Lamphier
August 2004

One
O, Say Can You See

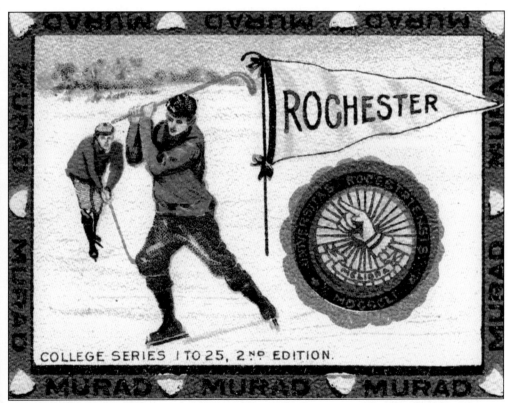

FIRE AND ICE. Rochester's early enthusiasm for ice hockey was memorialized in this cigarette premium issued with Murad cigarettes c. 1909. S. Anargyros' Turkish blend was marketed in colorful packaging and considered an upscale choice at 15¢ for a 10-pack. The 150-card college series depicted illustrations of various sports at different schools, but the University of Rochester was chosen as the location to feature the set's lone depiction of ice hockey.

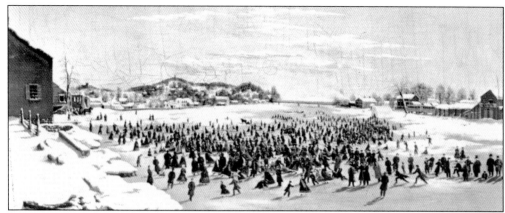

SKATERS ON THE GENESEE. This 1862 oil-on-canvas painting by Emily L. Smith was restored in 2004 through the efforts of the Rochester Historical Society. It depicts an early Rochester scene of hundreds of men, women, and children, including Union soldiers in military capes, enjoying what was already a popular pastime on the Genesee River during the Civil War. There are accounts from this era of adults complaining of young boys playing shinny—a descendant of the Scottish game of shinty and played with a ball and curved or bent stick on ice—while disrupting other people who were enjoying ice-skating as leisure. (Rochester Public Library Local History Division.)

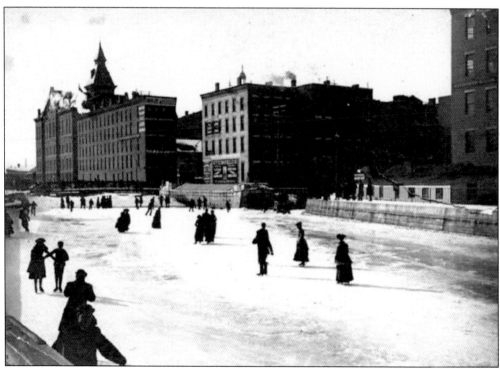

WINTER BECKONS. Ice-skaters on the Erie Canal, near Exchange Street, in this c. 1874–1883 photograph are adjacent to the site of the War Memorial, more than 70 years before its dedication. H. H. Edgerton's Exchange Street Rink was very popular for speed-skating competitions during this era. (Rochester Public Library Local History Division.)

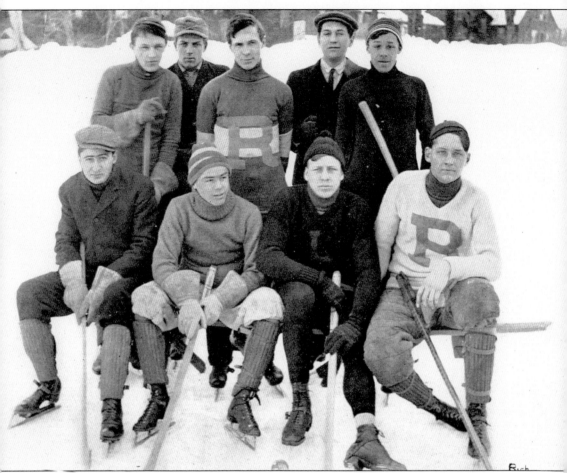

LEADING THE WAY. This is perhaps the oldest existing photograph of any Rochester hockey team. The 1904–1905 East High School squad compiled a 4-1 record against the Bradstreets, Ramblers, Genesees, and Ravens and outscored their opponents by an impressive 20-3 margin. Players, from left to right, are as follows: (first row) Walter White, Frank B. Donovan, Langdon Babcock, and Willis Linn; (second row) Raymond Bentley, William H. Lines (captain), Stanley Covell, Richard P. Hunt, and Herbert Hanford.

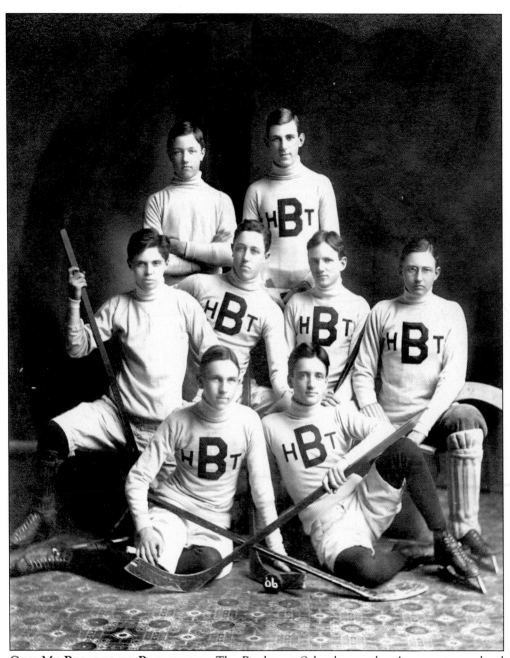

GIVE MY REGARDS TO BRADSTREET. The Bradstreet School was a boys' preparatory school founded by J. Howard Bradstreet and Elden G. Burritt in 1891. This 1906 team enjoyed a lively rivalry with East High's squad. Even after the institution closed its doors c. 1907, Bradstreet's alumni hockey team continued to take the ice against all takers, including the University of Rochester. Bradstreet players, from left to right, are as follows: (first row) Evershed Myers and George R. Fuller; (second row) Willis Clark, Brewster Lee, Harvey Jewett, and Osgood; (third row) Robert Lee and John Weiss. (Rochester Public Library Local History Division.)

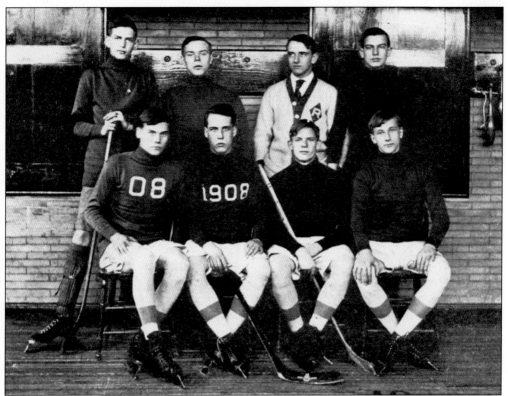

HAMMERING THEM HOME. Center Egbert Silvernail (second from left in the first row) captained the 1906–1907 East High team. He frequently tallied multiple-goal games and was described as still having his eye for shooting with him in his fourth year. One of his more notable games was played in the 1907–1908 season, when he tallied four of his club's five goals in a 5-1 victory over St. Paul's in a 40-minute (two halves) contest. Players, from left to right, are as follows: (first row) Arthur Boller, Silvernail, unidentified, and Montgomery Angell; (second row) unidentified, Miller Van Hoesen, Ben Heughes, and Robert Williams. (Rochester Public Library Local History Division.)

BASKET BALL HOCKEY
PECK & SNYDER, NORTH STAR, FISHER TUBE SKATES
TOBOGGANS, SKIS, SNOW SHOES
—ALSO—
GYMNASIUM AND ATHLETIC SUPPLIES
McCORD, GIBSON & STEWART
85 MAIN STREET EAST
BOTH PHONES EVENINGS UNTIL 7 O'CLOCK

THE ARRIVAL OF TUBE SKATES. Tube skates hit the general marketplace c. 1900 and revolutionized both hockey and speed-skating. The lightweight, steel-tube design, such as those manufactured by Fisher and sold through McCord, Gibson, and Stewart on Main Street East in Rochester, was a popular new generation of skates attached by the manufacturer at the factory as an extension of the boot or shoe in place of bulkier skates that were strapped to one's footwear. (Rochester Public Library Local History Division.)

Winter Sports

are healthful sports. They make red blood, strong limbs and good spirits. Nothing can be more bracing and exhilarating than good clean winter sports.

In our New Athletic Department

you will find everything for the enjoyment of this splendid season of sports. Our goods are selected with careful regard to superior quality and are unsurpassed in their line.

The Original Nestor Johnson Racing Skates

Endorsed by Peter Ostlund, champion amateur skater of the world, and all the most prominent skaters of the country. These skates are also as much used for pleasure as for speed.

With Shoes, $8.00. Without Shoes $5.00

Blauvelt *and* Spaulding Sweaters
Absolutely "The Best"

Made from the very finest quality of lamb's wool —soft and warm—in various weights. Just the thing for skating, driving, motoring, etc.

$4.50 to $7.50

We also make a specialty of made-to-order Sweaters.

Snow-Shoes Toboggans Hockey Sticks
Skating-Shoes Skis Skating Caps
Athletic Clothing of All Kinds

See our many fascinating games for long winter evenings.

22 MAIN STREET WEST

Scrantom, Wetmore & Co.
Rochester, N. Y.

Powers Block State and Main

BRACING AND EXHILARATING. In 1906, dealers of sporting goods enjoyed the prosperity that came with having a chief executive in the White House—New York's Theodore Roosevelt—who extolled the virtues of the sporting life. These merchants rode the wave of America's burgeoning delight with outdoor recreation. (Rochester Public Library Local History Division.)

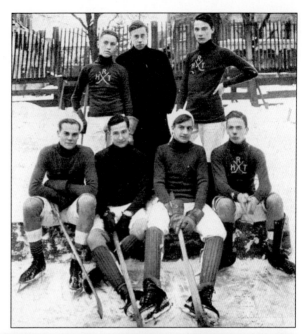

CLUB WITH AN EDGE. East High's hockey team of 1907–1908 had the confidence—or the temerity—to refer to themselves simply as the Rochester Hockey Team. The players even designed their own simple but effective uniform logo. Unlike their classmates on the ball field, court, and gridiron, East High's stick handlers were forced to pay for their own uniforms and equipment, with the exception of their sticks, if they qualified for the team. Team members, from left to right, are as follows: (first row) Arthur Boller (captain), Rudolph Siebert, Otho M. Clark, and Richard Finucane; (second row) Hilyard W. Taylor, Ray C. Badger, and Leo J. Sullivan. (Rochester Public Library Local History Division.)

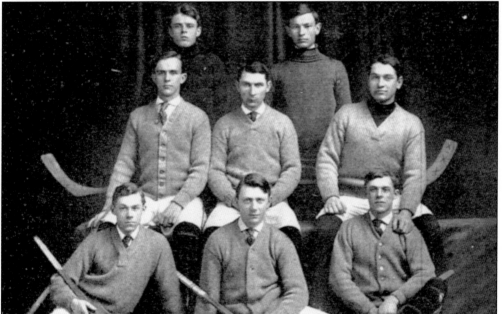

EAST HIGH HOCKEY GOES TO COLLEGE. The 1906–1907 University of Rochester (then located on Prince Street) varsity hockey club was the first group of icers in the institution's history. Captained by George T. Sullivan, who was a member of the first class of East High in 1903, the entire squad was composed of East High alumni who decided to form a team and compete against their alma mater, the Bradstreet team, Cornell University, and Niagara University. University of Rochester players, from left to right, are as follows: (first row) Herbert E. Hanford, Edwin H. Brooks, and William C. Hanford; (second row) Franklin H. Smith, George T. Sullivan, and Richard P. Hunt; (third row) Channing B. Lyon and Francis Gott. (Rochester Public Library Local History Division.)

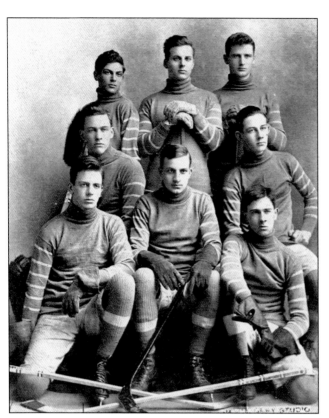

A Winter Carnival Feature. As part of a grand ice carnival at Genesee Valley Park that attracted thousands in February 1910, East High's hockey team met West High in a tight 1-1 contest at a rink erected for the event. Overall, this East High team captured a silver City Championship Cup, helped in part by goalie Edmund Ocumpaugh's two 1-0 shutouts versus West High and Bradstreet. Team members, from left to right, are as follows: (first row) Richard Finucane, Otho M. Clark (captain), and Halton Bly; (second row) Edmund Ocumpaugh and Paul Brown; (third row) Ray Rosenfeld, Burwell Abbott, and Ralph Babcock.

UNIVERSITY RINK

J. B. BREWER, Proprietor

Admission, 15 Cents
Season Tickets, $4.50

Skates Ground
Skates Repaired
Skates Rented

GOOD SKATING
IN SEASON

A Pond of Their Own. J. B. Brewer's University Rink on the East Side served as both a practice home and competitive ice for nearly a decade for, first, the East High club and then the University of Rochester teams. Brewer had previously established himself as a bicycle repairman extraordinaire at 194 East Avenue. He also underwrote the University of Rochester teams that were composed of young men who were, undoubtedly, repeat customers for both of his ventures. (Rochester Public Library Local History Division.)

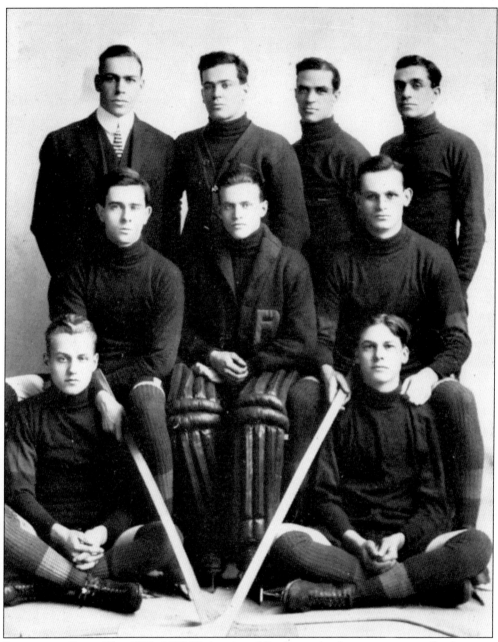

SIMPLY THE BEST. The 1911–1912 University of Rochester hockey team was easily the most talented and capable group of hockey players the school put on the rink in the pre–World War I era. The club outscored its opponents by a 13-2 margin, with its lone loss to Syracuse University. Team captain H. Archibald Mason, who was president of his class, captain of the basketball team, and a tight end in football in his spare time, notched three shutouts in goal. Players, from left to right, are as follows: (first row) Rudolph Schmidt and Charles Storer; (second row) Halton Bly, H. Archibald Mason, and Raymond J. Brown; (third row) Walter S. Forsyth, C. Forsyth, William E. Long, and Gradon Long. (Rochester Public Library Local History Division.)

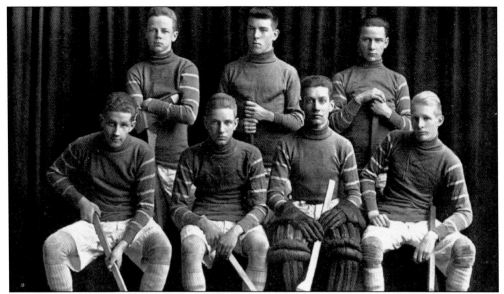

WESTERN NEW YORK'S FINEST. The 1912–1913 East High team posted a 6-1 record while outscoring their opponents 41-8 and capturing the city championship and a western New York scholastic title. The club continued its domination over West High with two shutouts of 12-0 and 5-0. Team members, from left to right, are as follows: (first row) Jack McCauley, Ralph Bickford (captain), D'Orville Doty, and Lathrop Sunderlin; (second row) Sanford Baker, Howard Beach, and John Sullivan.

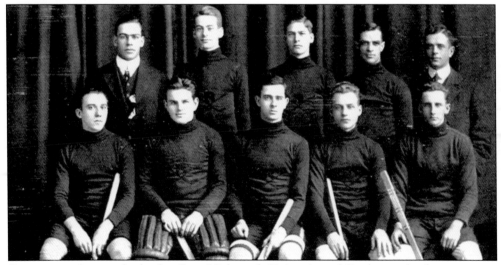

SWANSONG. Just as both the East High and University of Rochester hockey programs were reaching the peak of their potency, both teams lost their University Rink ice to the construction of new housing on the site for its female students. The 1914 annual included an anonymous farewell lament of feigned sorrow entitled "Ode to the Departing Skating Rink," which can be summed up with the line "And though we will surely miss the ice, Thou art our willing sacrifice." Team members, from left to right, are as follows: (first row) Percival Gillette, Chester Sage, Halton Bly (captain), Rudolph Schmidt, and Robert Patchen; (second row) Walter S. Forsyth, Lewis Sunderlin, Charles Storer, Edwin Long, and Dr. S. Douglas Killam (coach). (Rochester Public Library Local History Division.)

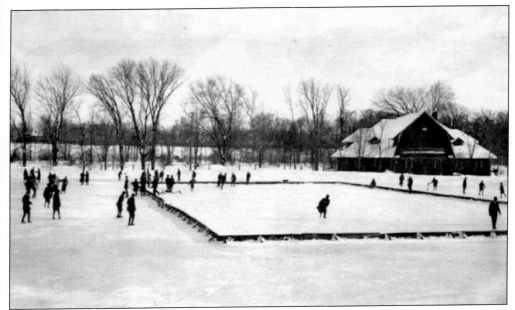

RINK ON THE RIVER. Speed-skating enjoyed a major revival in the Roaring Twenties, drawing literally thousands of visitors to Rochester competitions on rinks like this one at Genesee Valley Park. (Rochester Public Library Local History Division.)

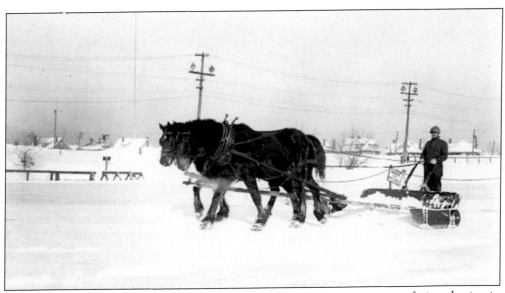

BEFORE THE ZAMBONI. The closest outdoor ice maintainers came to resurfacing the ice in the pre-Zamboni era was by this method of clearing snow, followed by a crew with a bucket of water and scrapers to periodically fill the cracks and imperfections in the ice surface. This worker demonstrates the use of horses to pull a snow scraper in advance preparation for a 1923 speed-skating event at Lake Riley in Cobbs Hill Park. (Albert R. Stone Negative Collection, Rochester Museum and Science Center.)

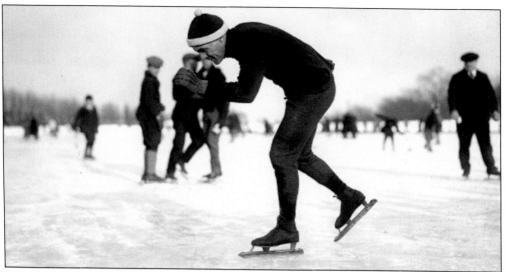

LIFE IN THE FAST LANE. Although hockey lay all but dormant in Rochester at the high school and collegiate levels after World War I, the speed-skating frenzy continued through the 1920s and even into the 1930s during the Great Depression. During this period, one man stood supreme in Rochester circles and epitomized the era's love for speed. Bert Bochmer, shown here c. 1923 at Lake Riley, conquered all foes an incredible 11 times in Rochester's annual skating meet. (Albert R. Stone Negative Collection, Rochester Museum and Science Center.)

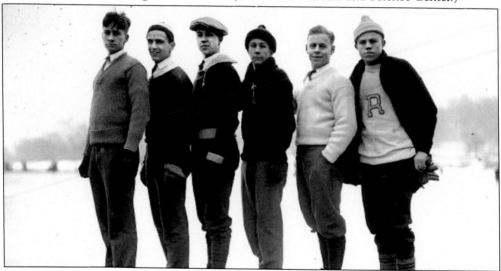

ON TO LAKE PLACID. This photograph illustrates the popularity of speed-skating at the high school level during the 1920s. These young men are shown at Lake Riley after winning events in a regional competition that enabled them to advance to the 1924 New York State Skating Championships at Lake Placid. Skaters, from left to right, are Pike Meade of East High, James Adams of Kodak High, Edward Rysewyk of East High, Alfred McClure of West High, Gregg Swarthout of East High, and George Sutphen of Technical High. Interestingly, Buffalo's Harry B. Taber, the co-founder of Rochester's first professional hockey team in 1935, came from the administrative ranks of speed-skating circles in western New York and promoted it with a phrase used in NHL circles at the time, "the Fastest Game on Earth." (Albert R. Stone Negative Collection, Rochester Museum and Science Center.)

Two

THE DAWN'S EARLY LIGHT

"THE FASTEST GAME IN THE WORLD"

Tonight ICE HOCKEY Tonight

EDGERTON PARK ARENA

ROCHESTER vs. LONDON

SEATS NOW ON SALE AT

| Rochester Sporting Goods, 11 State St. | HOCKEY CLUB OFFICE | Brownie's Marble Bar, 63 State St. |
| A. G. Spalding 114 St. Paul St. | 130 Powers Hotel Main 5095 | Seneca Hotel Cigar Stand |

Hall's Men's Wear, Inc., Sagamore Hotel

ROCHESTER PROFESSIONAL HOCKEY ARRIVES, FINALLY. The Rochester Cardinals were an expansion franchise of the early International Hockey League and the brainchild of Buffalo's Harry B. Taber, Syracuse's Mickey Roach, and an affiliate of the NHL's New York Americans. Taber named the team, rejecting a public contest and other suggested possibilities of Red Wings, Hustlers, Huskies, and Hickories. Originally scheduled to open at home against the Syracuse Stars on November 9, and then again on November 11, two failures of its new ice machinery, including 12 miles of refrigerated pipe under the arena floor, postponed the festivities twice until the third scheduled opener against the London Tecumsehs finally took place. Unfortunately, both the false starts and the opener—a tight one-goal loss—were harbingers of the Cardinals' star-crossed future.

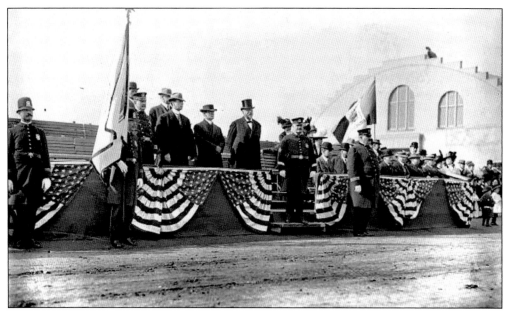

IN THE SHADOWS. Mayor Hiram Edgerton (center, with top hat) is seen here in 1911 at a patriotic annual review of the Rochester's police force at Exposition Park with Building No. 5. He was honored posthumously for his efforts when Exposition Park was renamed Edgerton Park in 1922. (Albert R. Stone Negative Collection, Rochester Museum and Science Center.)

HOME SWEET HOME. Building No. 5 at Exposition Park was built c. 1892 for use as the military drill hall of the State Industrial School. After the city acquired the property in 1911, Mayor Edgerton expressed his view that one of the buildings would be ideal as an indoor skating rink, but that was not realized until nearly 25 years later when, in the midst of the Great Depression, the city leased Building No. 5 for $3,500 to the ambitious Flower City Winter Sports Company, parents of the new Rochester Cardinals, for the 1935–1936 International Hockey League season. (Rochester Public Library Local History Division.)

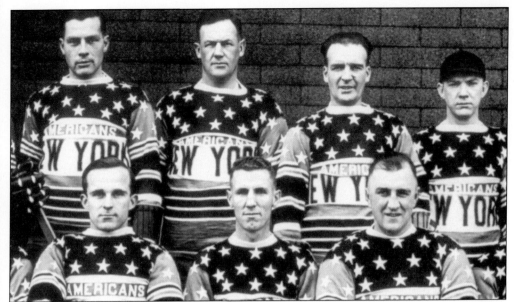

THE FIRST AMERKS. The New York Americans, owned by bootlegger "Big Bill" Dwyer, played in the first NHL game at Madison Square Garden in 1925 and were nicknamed the Star Spangled Skaters, Amercs, and Amerks by the press. This view of the 1926–1927 team includes goalie Vernon "Jumpin' Jack" Forbes, who came out of retirement to play five games in goal for the 1935–1936 Rochester Cardinals, and future Cardinals coach Mickey Roach, who persuaded Forbes to play in Rochester and negotiated the deal that established Rochester as an affiliate of the New York Americans. From left to right are the following: (first row) Vernon Forbes, Wilf "Shorty" Green, and Charlie Langlois; (second row) Billy Burch, Lionel "Big Train" Conacher, "Bullet" Joe Simpson, and Mickey Roach. Conacher's son Brian played a full season for the 1965–1966 Rochester Amerks. (Ernie Fitzsimmons Collection.)

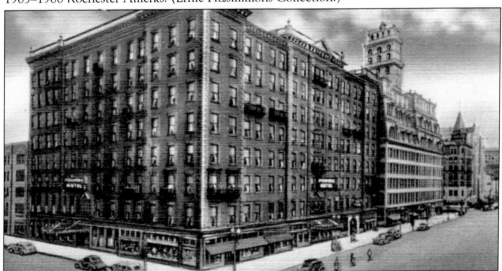

THE POWERS HOCKEY CONNECTION. The Powers Hotel, now the Executive Office Building, appears in the foreground of this postcard, while the famed Powers Building can be seen in the background. The Rochester Cardinals' offices were located in the Powers Hotel, while the Rochester Americans Hockey Club's offices were established in the Powers Building 20 years later.

23

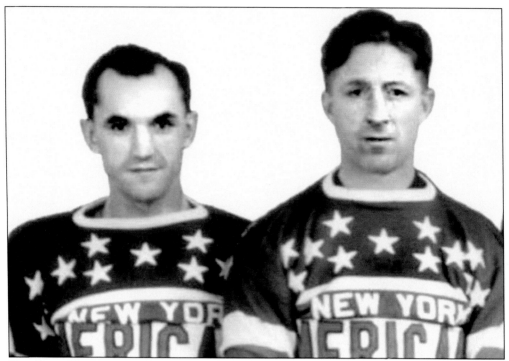

THE FIRST HOLDOUT. Nick Wasnie (left) and Mervyn "Red" Dutton were members of the New York Americans. Wasnie, a two-time Stanley Cup winner, became the Cardinals' first holdout—over traveling expenses. When he finally showed, Taber decided to trade him to the other IHL expansion team—the Pittsburgh Shamrocks. Wasnie, in turn, spoiled the Cardinals' visit to Pittsburgh on December 20 by firing the game-winning shot in overtime for a 6-5 Shamrock triumph. Hockey Hall of Famer "Red" Dutton was the player-coach who worked with Mickey Roach on the loaning of Amerk players to Rochester. (Ernie Fitzsimmons Collection.)

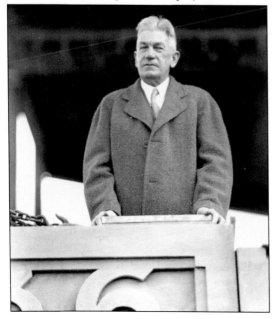

STANTON TALL. Mayor Charles Stanton, a principal architect of the city's attempt to bring professional hockey to Rochester, rebuffed opposition to the lease of Building No. 5 for that purpose. (Rochester Public Library Local History Division.)

INTERNATIONAL HOCKEY LEAGUE

CLUB DIRECTORY—SEASON 1935-1936

President
JOHN D. CHICK
951 McDougall St.
Windsor, Ontario, Canada

MEMBERS

CLEVELAND FALCONS
Cleveland Hockey Club, Inc.
Elysium, E. 107th and Euclid Ave.
Cleveland, Ohio
President........................Al Sutphin
Vice-President and Coach.......Harry Holmes
Home Ice.....................The Elysium
Colors.................Purple and White

DETROIT OLYMPICS
Detroit Olympics, Inc.
Grand River at McGraw
Detroit, Mich.
President......................James Norris
Secretary....................Arthur Wirtz
Manager and Coach..........Donnie Hughes
Home Ice......................The Olympia
Colors.................Black and White

PITTSBURGH SHAMROCKS
Pittsburgh Professional Hockey Club, Inc.
Duquesne Gardens
Pittsburgh, Pa.
President....................R. L. Babcock
Secretary....................P. C. Jackson
Manager and Coach........Sprague Cleghorn
Business Manager...........Larry F. Welch
Home Ice................Duquesne Gardens
Colors..................Green and White

LONDON TECUMSEHS
London Professional Hockey Club, Ltd.
London, Canada
President....................J. A. Anderson
Secretary....................C. R. Collyer
Manager and Coach.............George Hay
Home Ice....................London Arena
Colors............Green, Red and White

ROCHESTER CARDINALS
Flower City Winter Sports Co., Inc.
130 Powers Hotel
Rochester, N. Y.
President....................Ralph Reinhardt
Secretary.................Fred A. Reinhardt
Manager and Coach...........Mickey Roach
Home Ice..............Edgerton Park Arena
Colors................Cardinal and White

WINDSOR BULLDOGS
Windsor Professional Hockey Club, Ltd.
Windsor Arena
Windsor, Canada
President and Manager.........Harris Ardiel
Coach........................Dick Carroll
Home Ice......................The Arena
Colors.....................Red and White

BUFFALO BISONS
Peace Bridge Arena, Ltd.
Ft. Erie, Canada
President..................S. Edgar Danahy
Secretary.................George A. Vasey
Manager and Coach..........Frank Nighbor
Home Ice..............Peace Bridge Arena
Colors...........Black, Orange and White

SYRACUSE STARS
Syracuse Hockey Club, Inc.
118 Washington St.
Syracuse, N. Y.
President....................J. C. Johnson
Secretary......................Frank Read
Manager and Coach............Eddie Powers
Home Ice....................The Coliseum
Colors................Red, White and Blue

PAST INTERNATIONAL HOCKEY LEAGUE CHAMPIONS

1927	London Panthers	1931	Windsor
1928	Stratford	1932	Buffalo
1929	Windsor	1933	London
1930	Cleveland	1934	Detroit

IT'S IN THE BOOK. The 1935–1936 IHL directory included natural rivals in Rochester, Buffalo, and Syracuse. John Chick, IHL president, figured prominently in the Windsor, Ontario–based league's efforts to save professional hockey in Rochester and spent weeks of his time here away from his Canadian home in attempts to salvage the overextended enterprise. Fittingly, Chick, who knew firsthand the potential of fan support for hockey in Rochester, became the AHL president who oversaw the return of the professional sport in 1956.

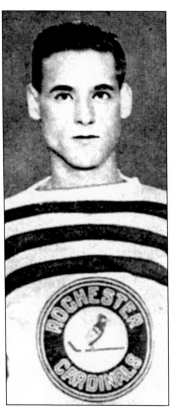

GREAT SCOT. Scottish-born center Ralph Rennie was selected captain of the Rochester Cardinals by Roach as "recognition for his brand of stick wielding" and for "his ability to lead the sextet." He proved he was a team leader and finished second that year in team goals (11) and third in assists (17). The likeable Meigs Street resident's popularity was enhanced by the fact that he owned a Packard of ancient vintage that he had acquired for $30 and effectively became a team vehicle. He also worked for Eastwood and Son's shoe store on East Avenue.

WAITING FOR MOE. The Rochester Cardinals were designed and built around one man, a keen-eyed "agile as a cat" American-born Jewish goaltender and former milkman named Moe Roberts. However, the rights to Roberts were claimed immediately after preseason camp in Oshawa by both the New York Americans and the IHL's Cleveland Falcons. IHL president Chick quickly ruled that Roberts was Cleveland's concern. New York then filed a protest with NHL czar Frank Calder, who promised to rule on the matter within a week, which turned into nearly two months. In doing so, Calder unwittingly sparked public interest in the team in general and Roberts in particular. (Society for International Hockey Research.)

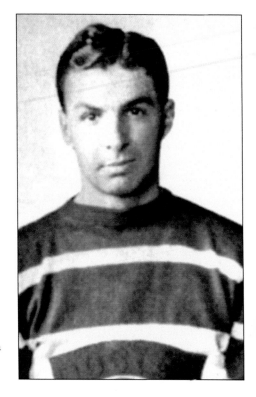

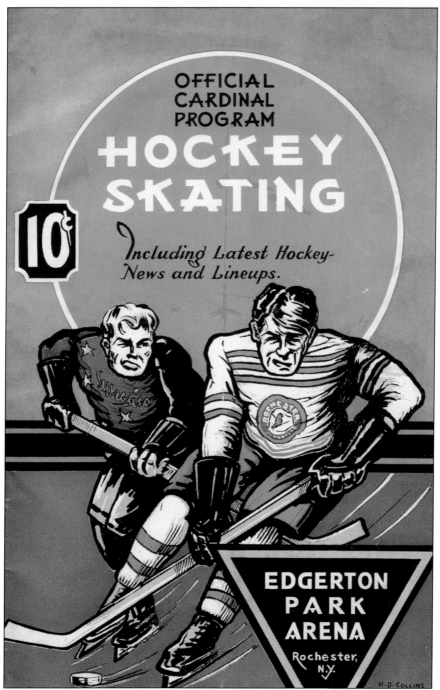

GET WITH THE PROGRAM. The cover of an extremely scarce Rochester Cardinals program indicates that the promoters called Building No. 5 at Edgerton Park the Edgerton Park Arena almost immediately. The abundance of available advertising space coupled with the lack of any photographs or profiles of team members in this December 10, 1935, program is indicative of a club that was struggling to meet payroll and would file for bankruptcy in court before year's end, despite ranking fourth in league attendance.

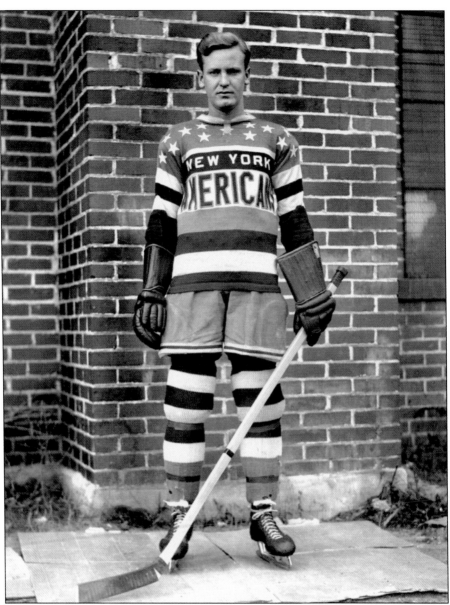

THE BOY WONDER. Through all the Cardinals' woes, Toronto's Walter "Whitey" Farrant, who turned professional with Rochester, was a constant source of pure enjoyment for local hockey fans throughout the 47-game season. Over a six-game stretch from February 8 to 22, 1936, "Whitey" put on an astounding offensive display of 11 goals that caught the eye of more than one NHL scout and resulted in offers—rejected by Cardinal management—to ship him elsewhere. His torrid run began with an uncontested four-goal stretch on the road at Cleveland's Elysium, scoring the game's last tally of the second period and notching three more—including the game winner—in a less than 12-minute span in the final stanza, leading the Cardinals to a 6-3 triumph. The following game, Whitey terrorized Cleveland again, this time in Rochester, with two goals and an assist. He finished the season with 26 of the team's 104 goals, a remarkable 25 percent, and ended up third among league goal leaders and sixth in overall scoring, while recording five game winners for the Cardinals. (Ernie Fitzsimmons Collection.)

BURYING THE OPPOSITION. A 22-year-old center and off-season gravedigger who was born in North Dakota and raised in Minneapolis, Earl Bartholome played in every Cardinal game and became known to Rochester fans as a consummate team player and catalyst. The *Rochester Democrat & Chronicle* indicated that the Ravine Avenue resident was "regarded by many as the best prospect on the Cardinal roster," and by the season's end, he bolstered that claim by finishing the campaign as the club leader in assists with 21 and second in total points only to Farrant.

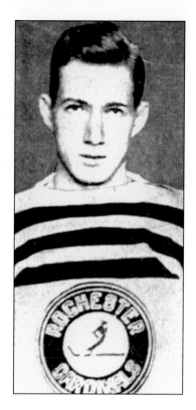

IRON MAN. Andy "Iron Man" Bellemer was one of only four Cardinal players who remained under contract to the club—as opposed to being loaned to the team and the property of another franchise—after the team's bankruptcy proceeding. Along with Ralph Rennie, Earl Bartholome, and Nakina Smith, the signed quartet was nicknamed "Coopie's Little Orphies" and "the Orphans" by the Windsor newspapers. Bellemer was solid throughout the year on an injury-riddled defensive corps, playing 45 of 47 games for the Cardinals and sometimes playing nearly every shift. He was best known for his ability to absorb and deliver punishment.

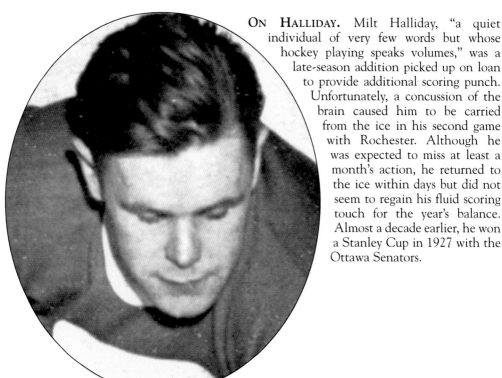

ON HALLIDAY. Milt Halliday, "a quiet individual of very few words but whose hockey playing speaks volumes," was a late-season addition picked up on loan to provide additional scoring punch. Unfortunately, a concussion of the brain caused him to be carried from the ice in his second game with Rochester. Although he was expected to miss at least a month's action, he returned to the ice within days but did not seem to regain his fluid scoring touch for the year's balance. Almost a decade earlier, he won a Stanley Cup in 1927 with the Ottawa Senators.

OUR LONE RANGER. Patsy Callighen, known as "a mainstay of the Cleveland defense through his ability to break up fast plays of the opposing teams, hard body checking and dependability," was traded to the London Bulldogs during the season and acquired by Rochester. Roach touted Patsy Callighen's experience, for he had been a member of the 1927–1928 New York Rangers, the first American-based NHL team to hoist the trophy. As a Rochester Cardinal, he tallied two goals and an assist in 13 games.

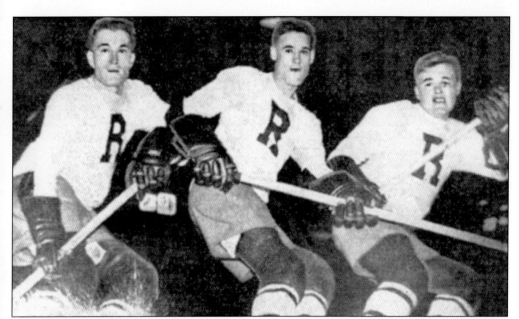

THE FIRST FRONT LINE. Rochester's first professional front line consisted of, from left to right, right wing Hal Picketts, center and captain Ralph Rennie, and left wing Evy "Ebbie" Scotvold. They are seen here practicing at Edgerton Park Arena prior to starting the opening game versus the London Tecumsehs on November 12, 1935. After the double failure of the ice plant twice earlier that week, the third time proved a proverbial charm, but the crowd, which was expected to be a sellout at 3,030, was discouraged by the two earlier sputters and dwindled to just 1,500. London broke a third-period tie to take the contest 3-2—Rochester's first of 14 one-goal losses.

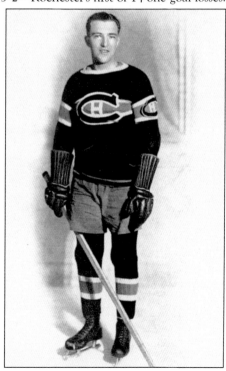

THE FIRST GOAL. Leo Lafrance, shown here with the Montreal Canadiens, had a brief NHL stint in the 1920s but left his mark on Rochester's professional hockey history by netting the first regular season professional goal ever for a Flower City team against London in the Cardinals' opener. His unassisted goal tied the team's opening contest at 1-1 with less than two minutes to play in the first period. His efforts were described as part of dervish rush in which he took "the puck alone the whole route" and rifled it "through the legs of the squat (Herb) Stuart and almost through the net." The goal was his only tally in just nine games for Roach's Rovers.

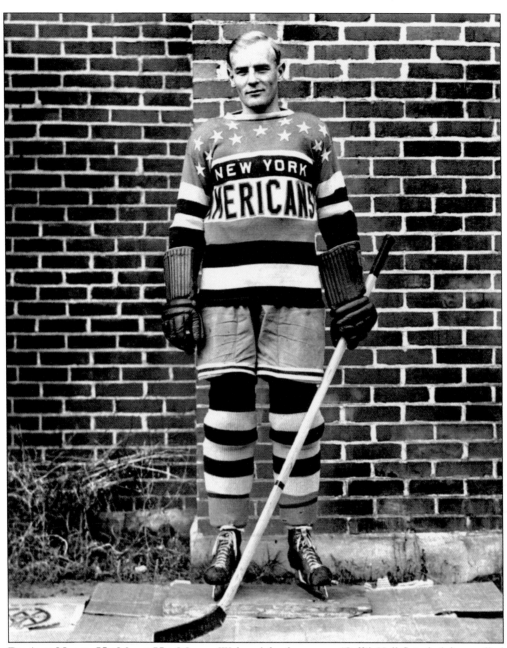

BY ANY NAME, HE MADE HIS MARK. Walter (also known as "Jeff") Kalbfleisch (also spelled Kalbfleish) was noticed "hanging around the Oshawa training quarters" by coach Mickey Roach. Kalbfleisch was acquired by the New York Americans in the Dispersal Draft in October 1935, subsequent to the demise of the NHL's St. Louis Eagles. He played a major role in the Cardinals' defense for 21 games while adding three goals and two assists for five points on offense. After his year in Rochester, he became the first former Cardinal to win a Calder Cup in 1938 while with the Providence Reds. (Ernie Fitzsimmons Collection.)

PART OF THE DUTTON DEAL. Mike Neville was acquired by the Amerks in a trade with the Montreal Maroons that brought future player and coach Red Dutton to New York. Dutton later loaned Neville to Rochester as part of the affiliation agreement, where he spent 39 games while logging two goals and two assists for the Cardinals. (Society for International Hockey Research.)

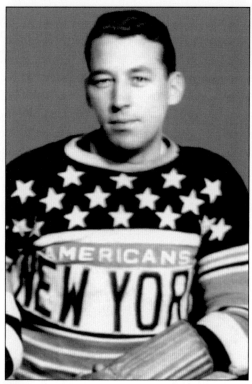

ELMER'S TUNE. Mickey Roach watched Elmer "Tony" Hemmerling's progress with various minor league teams during the 1930s and sought his assignment to Rochester by Red Dutton. Dutton granted Roach's wish, and Hemmerling helped the club almost immediately on a line with Whitey Farrant, driving home three goals and five assists for eight points in 11 games. Unfortunately for the Cardinals, Hemmerling was reassigned midseason to the New Haven Eagles. He later scored 34 goals over two seasons (1940–1942) with the AHL's Buffalo Bisons. (Ernie Fitzsimmons Collection.)

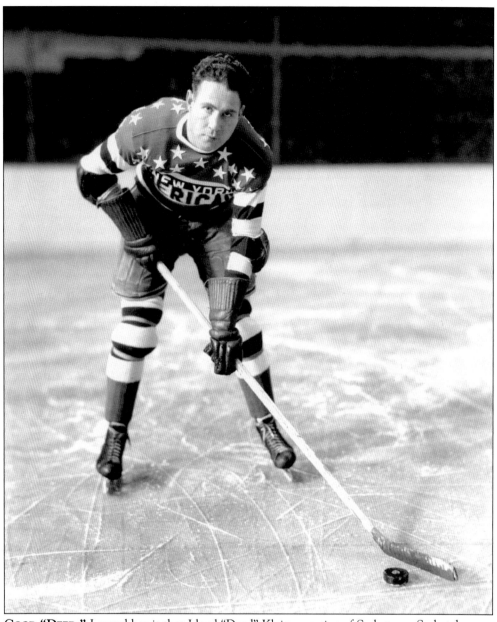

Good "Deed." Legend has it that Lloyd "Deed" Klein, a native of Saskatoon, Saskatchewan, was such a large baby at birth that his father exclaimed, "Indeed!" when he saw him—hence the nickname. Regardless of whether this is true or not, Klein made a whopping impact in his brief but welcomed visit to Rochester as a member of the Cardinals. In his first NHL season, while still a teenager, Klein was a member of the Boston Bruins' first Stanley Cup champion team in 1928. In 1933, he was acquired by the New York Americans in a trade with Boston and appeared in 134 games with the Amerks over the next four years. When Mickey Roach sent out the call for help in Rochester, Klein was one of the many players who did brief tours of duty at Edgerton Park Arena in a Cardinals uniform. What was different about Klein is that he found the net on three occasions, plus an assist, in just four games, including a game winner against Buffalo in Rochester on January 23, 1936. (Ernie Fitzsimmons Collection.)

STARKE TIMES. On the night of December 20, 1935, Joe Starke was in goal for Pittsburgh when former Cardinal Nick Wasnie buried the Cardinals 6-5 with an overtime game winner. Roach had to return borrowed goalie Alex Wood to Buffalo after the game and was in a quandary as to who would start the game the following night in Cleveland, since his backup goalie Jake Forbes was out with four broken ribs. Pittsburgh's brass consented to allowing Starke to make the trip with the Cardinals to Cleveland, and Starke lost 4-3 to the Falcons in his lone game for Rochester. (Society for International Hockey Research.)

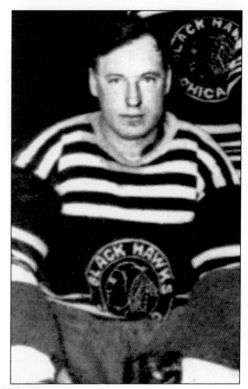

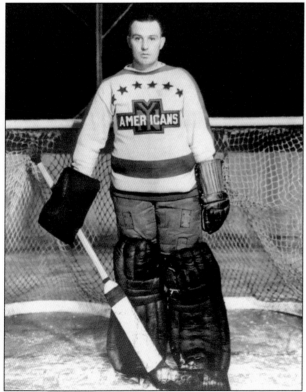

THE EARL OF GOALIES. Earl Robertson also appeared on emergency loan to the Cardinals, in this case from the New York Amerks, for two games in December 1935. Despite his reputed abilities, he fared no better than Starke, Wood, or Baxter in Rochester's crease. In fact, the four goalies combined were winless at 0-12 in their numerous appearances before Moe Roberts finally appeared in net for the Cardinals. Robertson fared much better in later years, earning distinction for helping the Detroit Red Wings win their second straight Stanley Cup in 1937 and earning a victory in the first-ever AHL All-Star game in 1942. (Ernie Fitzsimmons Collection.)

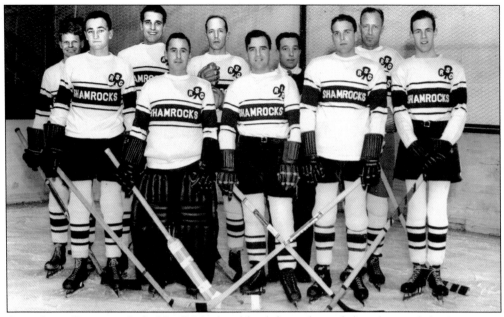

AYE, AYE, CAPTAIN. Jack "Cap" Manley (third from the right), a licensed ship's captain, relocated to Rochester from Chicago to transform Building No. 5 into Edgerton Park Arena in the fall of 1935. Once in Rochester, Manley served as coach of the Rochester Sporting Goods (RSG) Shamrocks of the six-member Rochester Amateur Hockey League, nicknamed the "Dusty League," due to teams being sponsored by Rochester's leading industries. League president Robert B. Kidd, a former Cornell University player, joined Manley on the Shamrocks and is pictured second from the right. Cardinal players served as referees for the league's contests. The amateur circuit, which played all of its games at Edgerton Park Arena, was immensely popular with local fans and often outdrew the Cardinals. When Buffalo's Harry B. Taber was ousted by a court-appointed trustee as the Cardinals' general manager on New Year's Day 1936, after the team's dismal 2-14 start, "Genial Jack" Manley assumed the team's reins. The change was applauded in the local press, and Manley responded by helping to navigate the Cardinals' shift in fortunes, which included a dramatic albeit unsuccessful second-half playoff push. (Rochester Public Library Local History Division; photograph by Harold Lara.)

Rochester Sporting Goods Co.

11 STATE STREET
(POWERS BUILDING)

Official Hockey and Skating Equipment

CCM and Alfred Johnson Skates

Athletic Outfitters for over a quarter of a century

WOLVERINES REUNITED. On December 10, 1935, the Cardinals hosted the IHL defending champion Detroit Olympics for the first time. The Olympics' powerful lineup featured former University of Michigan All-American star forward and captain of the 1934–1935 Big 10 championship team Johnny Sherf (on the left). University of Michigan alumni in Rochester turned out to welcome Sherf, and among them was his former Wolverine teammate, Don "Red" MacCollum (on the right) of the Rochester Gas and Electric Club of the Rochester Amateur Hockey League. When Sherf was photographed with MacCollum, he chuckled, "So you spoiled it all and went to work for a living." The Olympics won 2-1 that evening. (Rochester Public Library Local History Division; photograph by Harold Lara.)

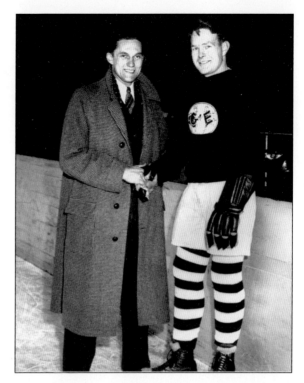

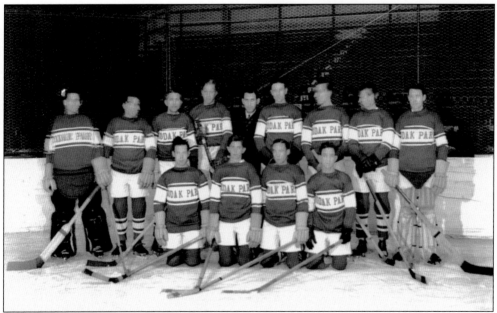

MOVING PICTURE? Members of the Kodak Park team of the Rochester Amateur Hockey League were on hand that night as well. After the Cardinals game, fans were treated to a game of broomball between members of the new Dusty League. Of all the league's six teams, however, one would expect that the KayPees would have known a thing or two about cameras and stayed still for Lara's shutter. (Rochester Public Library Local History Division; photograph by Harold Lara.)

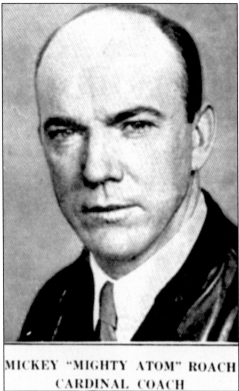

MICKEY "MIGHTY ATOM" ROACH
CARDINAL COACH

OUTGOING COACH. This photograph was taken prior to Mickey Roach's departure as coach of the Rochester Cardinals. During his 21 games of piloting the team, the Cardinals were incapable of transcending their many struggles on and off the ice and finished his tenure with a 4-16-1 record prior to his replacement by Carson Cooper. A relatively successful forward for the Hamilton Tigers in the 1920s, he was inducted as an inaugural member of the Nova Scotia Sport Hall of Fame in 1980, just three years after his death.

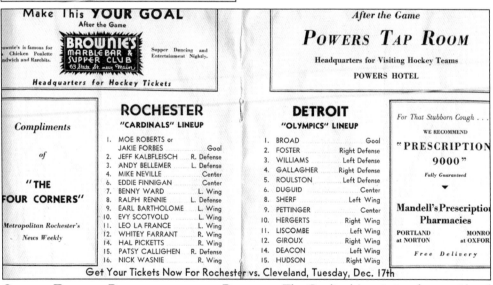

CANNOT TELL THE PLAYERS WITHOUT A PROGRAM. The Cardinals' optimism for a rapid end to the dispute regarding Moe Roberts's status is evident in the program's reference to the goalie being either "Moe Roberts or Jakie Forbes." Note the promotion for the next home game on December 17. On that evening, the Cardinals underwent the indignity of not only having the game receipts seized by the sheriff, but their equipment as well. Loaned Buffalo goalie Alex Wood cackled like a hen when the sheriff arrived and the Cardinals' management saw to it that he received his $50 for the evening.

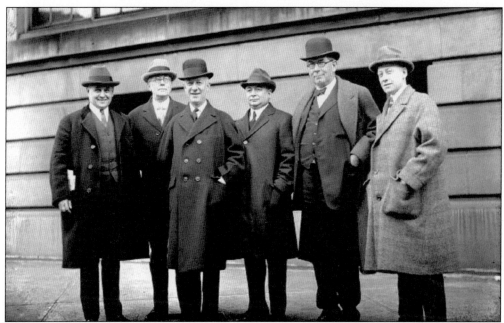

COURT IS IN SESSION. Federal judge Harlan W. Rippey (fourth from the left) is seen here with New York governor Alfred E. Smith (third from the left) in 1924. Rippey supervised the bankruptcy hearings pertaining to the Flower City Winter Sports Company. He saw to it that the club's players were allowed to continue to use their equipment and uniforms and tried diligently to keep the financial issues separate from the team's play. Speculation was fueled and the papers were abuzz with potential buyers. Finally, IHL president Chick seized the operation and ran the team. When the question arose as to whether or not Chick would coach the team from the bench, he appointed Carson Cooper coach immediately and quipped, "Wouldn't I look good, calling a referee that I named to handle the game 'blind'?" (Albert R. Stone Negative Collection, Rochester Museum and Science Center.)

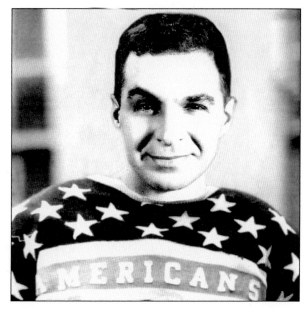

NEW KID IN TOWN. Between Moe Roberts's debut and a new schedule of lower prices at Edgerton Park Arena, the combination saw 3,217 fans turn out for the January 4, 1936, game against Syracuse. Although the Cardinals lost 2-0, Roberts was very impressive in goal and instantly became the fan favorite. Just three nights later, on January 7, Roberts led a 3-16 club against the defending league champion Detroit Olympics, who had lost only two road games all season, and bested goalie Turk Broda and his teammates with an astounding 3-0 shutout victory. (Ernie Fitzsimmons Collection.)

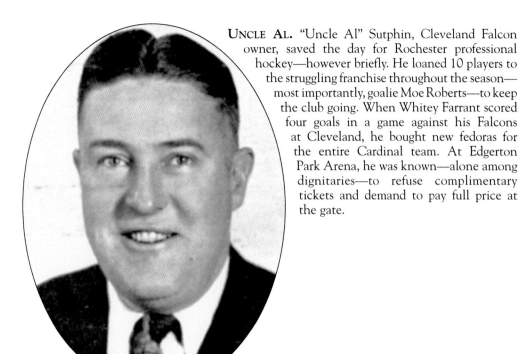

UNCLE AL. "Uncle Al" Sutphin, Cleveland Falcon owner, saved the day for Rochester professional hockey—however briefly. He loaned 10 players to the struggling franchise throughout the season—most importantly, goalie Moe Roberts—to keep the club going. When Whitey Farrant scored four goals in a game against his Falcons at Cleveland, he bought new fedoras for the entire Cardinal team. At Edgerton Park Arena, he was known—alone among dignitaries—to refuse complimentary tickets and demand to pay full price at the gate.

DO YOU HEAR WHAT I HEAR? The Cardinals are clowning for the photographers outside of the team office during meetings on the team's status and player affiliations. Once the Cardinals could put Roberts in goal, he went on to post an 8-6-1 record, including two shutouts, before pressure from the Cleveland media and fans became so great on Sutphin that Roberts was finally recalled to the Falcons. Roberts posted three more shutouts before the season's end in a Falcons sweater and ended up leading the league with a 2.03 GAA. Players, from left to right, are Ralph Rennie (captain), Dalton "Nakina" Smith (forward), Earl Bartholome (foreground), Walter "Jeff" Kalbfleisch (leaning against door), Roberts, and Roger Cormier.

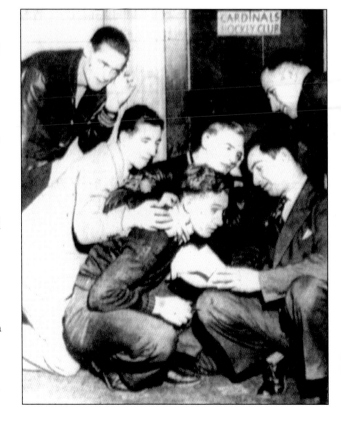

Nice Fellows Here..But On The Other Side of That Fence Smiles Turn to Frowns

CARDS TAKE WING. By February 15, 1936, the Cardinals' recent success merited a team photograph. This photograph is the only known picture of the team in their Cardinal red-striped garb with a center crest with sky-blue lettering, and it features the team at its peak. Team members, from left to right, are Mike Neville, Earl Bartholome, Dalton "Nakina" Smith, Ralph Rennie (captain), Whitey Farrant, Moe Roberts, Farrand Gillie, Ellis Pringle, Red Anderson, Bill Cunningham, Andy Bellemer, and Mike Brophy. At the time the photograph was taken, Rochester had the rights to only one-third of those pictured—Neville, Rennie, Pringle, and Bellemer.

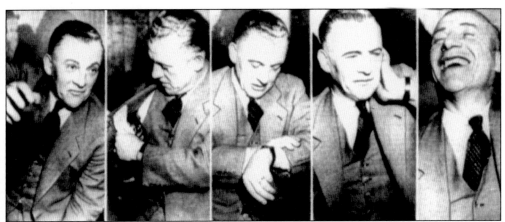

MAN OF A THOUSAND FACES. Both the Cardinal players and the Rochester public welcomed the animated good nature of Carson Cooper behind the bench. The "Silver Fox" is captured here displaying a series of antics while behind the bench during a game versus Buffalo in February 1936. His turnaround of the team so impressed Al Sutphin that he brought Cooper to Cleveland to coach his Falcons for the 1936–1937 season.

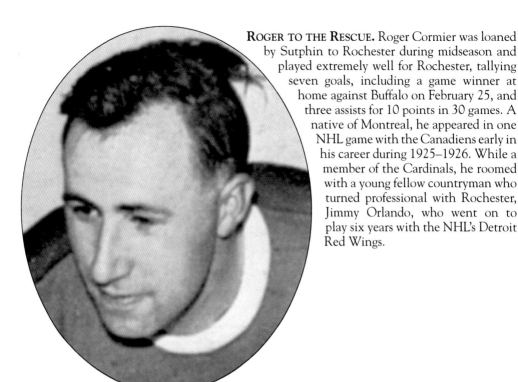

ROGER TO THE RESCUE. Roger Cormier was loaned by Sutphin to Rochester during midseason and played extremely well for Rochester, tallying seven goals, including a game winner at home against Buffalo on February 25, and three assists for 10 points in 30 games. A native of Montreal, he appeared in one NHL game with the Canadiens early in his career during 1925–1926. While a member of the Cardinals, he roomed with a young fellow countryman who turned professional with Rochester, Jimmy Orlando, who went on to play six years with the NHL's Detroit Red Wings.

STRONG SUIT. Perhaps one of the best-dressed men in hockey's early history, the "Italian kid" and future Stanley Cup champion was known for his taste in fine clothes, but that should not obscure the fact that his defensive skills were sometimes second to none. Media accounts indicate that Orlando spoke Italian, French, and English fluently and that he could be heard talking to his roommate Cormier in any or all of the languages in their animated conversations. The Cardinals were his first professional team. (Society for International Hockey Research.)

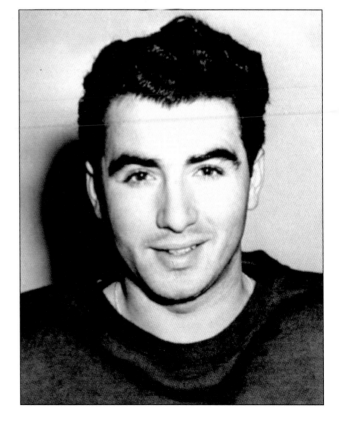

SPLIT SHIFT. Dalton "Nakina" Smith, a native of Cache Bay, Ontario, was an original member of the Rochester Cardinals and appeared in four scoreless games before being promptly loaned to the London Tecumsehs. After 12 games with London, Smith returned, seemingly, a new man. The press praised the one-time fur trapper as he contributed five goals and eight assists for 13 points in his second tour of duty. He was named a two-time AHA All-Star with the Minneapolis Millers in 1939 and 1940.

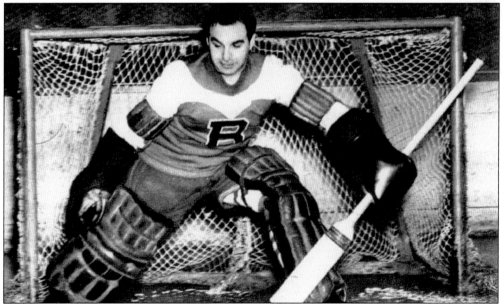

GOING WEST. Moe Roberts enjoyed a stellar, albeit brief, experience with the Cleveland Barons after his days with the Cardinals were done. Unusual for a goalie, he captained the team to its first Calder Cup in 1939, and as a first-team all-star, he led them to a second Calder Cup two years later. His 22 shutouts rank 11th in AHL history, while his first and last NHL appearances were an incredible record 18 years apart. Years later, the great Gordie Howe broke his record as the oldest active NHL player in league history.

THE PLUCK OF THE IRISH. Mike Brophy came to the Rochester Cardinals from the Cleveland Falcons with a well-established reputation of being a solid and durable competitor. While his scoring talents were beginning to ebb by the time he arrived in the Flower City, he contributed to the Cardinals frequently throughout the second half of the season, including three goals in his first four games. A team program described him as "strictly a fighter, which is easily explained because Mike is strictly Irish."

TRUE CONFESSIONS. Some two generations before the music genre and the international restaurant chain of the same name were established, Harvey "Hard Rock" Rockburn was known as "one of the hardest men in the league for the forward line to pass." A former NHL penalty minutes leader, he spent most of 1935–1936 with Cleveland and noted to the press assembled at the Powers Hotel after a seemingly grueling contest with the Cardinals that it was "a pink tea party compared to some I have been through." Late in the year, Rockburn was loaned briefly to Rochester. The combative Park Avenue resident and "armored car" was known to attend Mass every morning.

WAITING IN THE WINGS. At the start of the 1935–1936 season, Bill Taugher was thought to be the best goaltender in the IHL; in 1930–1931 and 1931–1932, he posted a remarkable 13 shutouts each season to lead the league in the category while posting a GAA of 1.56 and 1.67, respectively. But when Moe Roberts was recalled to Cleveland, Bill was sent to Rochester for the 15 remaining games of the season. Taugher posted a 5-8-2 record with a depleted Cardinal lineup and finished the year with a GAA of 2.92—a distant cry from his great numbers of the early 1930s.

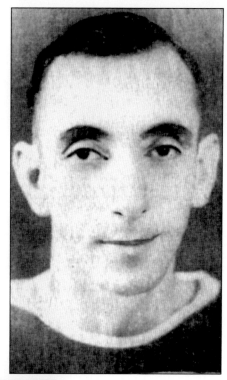

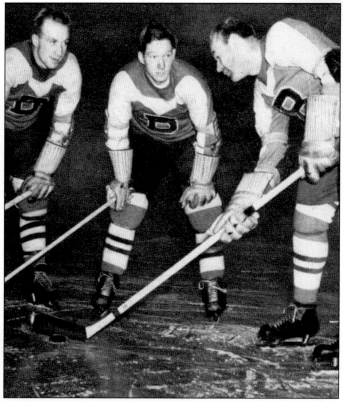

EARL'S A BARON. Cardinal star Earl Bartholome went to Al Sutphin's Cleveland team with Moe Roberts, won three Calder Cups, and became the first American-born professional to play more than 500 games with one franchise. In 1977, he was inducted into the U.S. Hockey Hall of Fame. When he passed away at the age of 88 in 2002, he was believed to be the last surviving member of the Rochester Cardinals. Rochester fans were fortunate to witness his early development here at Edgerton Park.

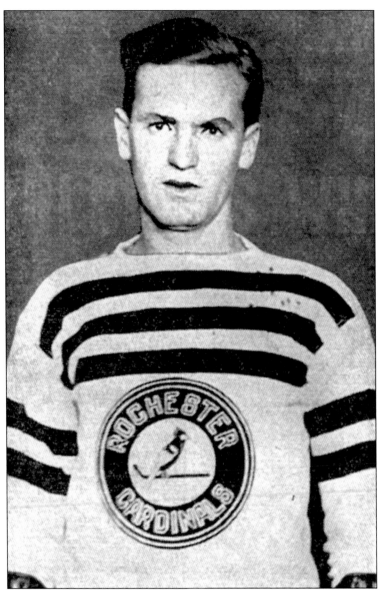

HATS OFF TO WHITEY. Whitey Farrant set the standard for tenacious offense and precision with his shots, finding the net 26 times in just 47 games in his first professional season here in Rochester. Although IHL president Chick promised Rochester fans hockey for the 1936–1937 season, the plans of having a professional team here were derailed by a league merger with the Can-Am League to form the IAHL, eventually known as the AHL. Although his career in Rochester was done, Farrant ended up with the Minneapolis Millers of the AHA and demonstrated his goal-scoring abilities there with a total of 82 goals over three full seasons (1937–1940). However, his dream of making it to the big show occurred for just one game, as an injury replacement, with the Chicago Blackhawks in 1943–1944. He did, however, accept an invitation to appear in an NHL Oldies Game in his home town of Toronto at Maple Leaf Gardens on April 12, 1953. Less than four years later, Bronco Horvath brought the same kind of precision and accuracy Farrant displayed in Rochester and was to the Rochester Americans in their first season what Farrant was to the Cardinals a generation earlier.

Three

SO PROUDLY WE HAILED

ANOTHER CLEVELAND CONNECTION. After two decades of waiting for the return of professional hockey to Rochester, King Clancy reacquainted Rochester fans by conducting a free public hockey clinic at the War Memorial with several Amerks players just six days before the home opener. "A crowd of more than 2,000 watched demonstrations and scrimmages by star-spangled Amerks." On Sunday, October 14, 1956, the franchise home opener, expected to draw 5,000, ended up attracting 6,306 new fans who witnessed a 2-2 tie with the Cleveland Barons.

47

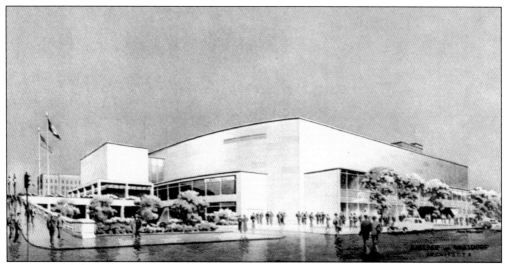

IF WE BUILD IT. The Community War Memorial was intended to be "an everlasting tribute to those who fought and served in our nation's wars." The fact that the facility should be a "living memorial rather than a mere commemorative monument" was stressed from the onset of planning in 1945, and the notion of including a major sports arena as part of the design was already established by that time. The city demolished the 71-year-old William S. Kimball Tobacco Factory, which stood on the site of the present-day Blue Cross Arena at the War Memorial, in 1951. By 1953, the Rochester Community War Memorial was dedicated and construction began, while the facility opened two years later on October 16, 1955, at a cost of $7.5 million. From March 1996 through September 1998, the War Memorial was the site of a $41 million upgrade, expansion, and subsequent rededication. The Rochester Americans have called it home since their first game. (Rochester Public Library Local History Division.)

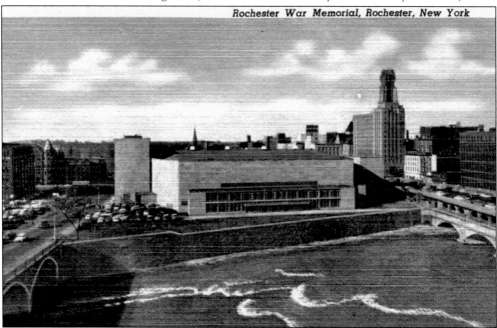

GOOD NEIGHBOR SAM. For Sam Toth, nicknamed "the Father of the Rochester Americans," there was no job too big or too small to handle, and there was no task that he was unwilling to assume to see his dream of professional hockey in Rochester realized and cultivated. A great visionary, he was an amateur hockey player and promoter of amateur hockey in the early 1950s, playing games at Genesee Valley Park's rink and scheduling opponents for teams like the Rochester Packers. Both he and friend Ed House even served as linesmen at home games at the War Memorial for the early Amerk contests, and both of them ended up between blows of friend and foe AHL combatants on more than one occasion. Toth also served as an owner, president, and off-ice official during his years with the club. He was elected to the Rochester Americans Hall of Fame in 1998, while House was added in 2003. (Sam Toth.)

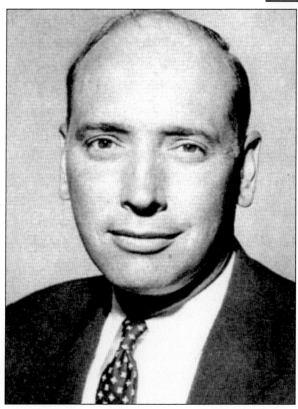

THE ORGANIZER AND REORGANIZER. Robert W. Clarke is considered the organizer of the Rochester Americans Hockey Club franchise at the point of its entry into the AHL. Along with Morrie Silver of Rochester baseball fame and Fred Forman, he pursued and coordinated the original team purchase and the ownership arrangement with the original Montreal and Toronto parent clubs. He was also the club's first secretary-treasurer, while Silver was an original vice president of the club and Forman served as a director. The AHL has honored him on several occasions, most recently naming him an honorary lifetime member in 1999.

REAY OF HOPE. Head coach Billy Reay, a two-time Stanley Cup champion (1946 and 1953) and whirlwind center with the Montreal Canadiens, knew the meaning of winning, expected a lot from his players—many of whom had won some silverware of their own—and drove them to reach their top potential. Through perseverance, reconfiguring lineups, and intense practice drills, he balanced the outstanding seemingly incompatible charges that were made available to him from the divergent styles of both Montreal's finesse system versus Toronto's rough, power brand of hockey and brought a team that was winless in its first eight games to a 34-25-5 record, good for a 73-point third-place finish—just three points behind AHL defending champion Providence Reds. Although the Amerks lost in the second and final Calder Cup round to Cleveland, Reay's leadership in guiding the club's formidable run for the league title was remarkable with a first-year team, and he was promoted to the head coach's position with the Toronto Maple Leafs at the end of the season. He later assumed head coaching duties with the Chicago Blackhawks, where he earned his greatest fame. He ranks sixth in overall NHL coaching victories. (Rochester Americans.)

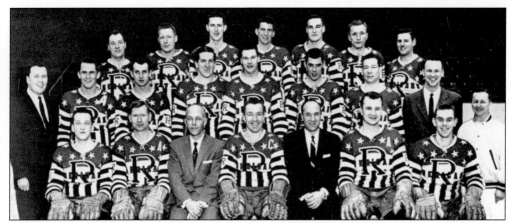

THE 1956–1957 ROCHESTER AMERICANS. Team members, from left to right, are as follows: (first row) Al Langlois, Tommy Williams, Paul Bibeault (general manager), Gordie Hannigan (captain), Billy Reay (coach), Benny Woit, and Bob Duncan; (second row) John Clapp (publicity director), Gary Collins, Bronco Horvath, Eddie Mazur, Ab McDonald, Earl Balfour, Joe Lund, Paul Napier (promotions director), and Russ Higgins (trainer); (third row) Bobby Perreault, Ron Hurst, Billy Harris, Mike Nykoluk, Gary Aldcorn, Paul Masnick, and Gil Boisvert. Both Mazur and Masnick were teammates with Billy Reay on the 1953 Stanley Cup champion Montreal Canadiens, while Benny Woit won three Stanley Cups with the Detroit Red Wings before arriving in Rochester. Six members of this team—Horvath, Mazur, Masnick, Hannigan, McDonald, and Balfour—topped 20 goals that season. (Rochester Americans.)

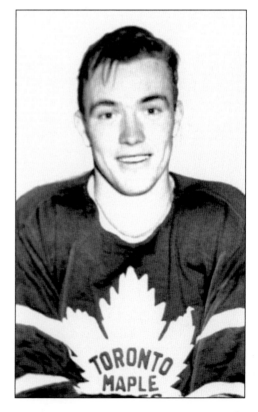

FIRST CAPTAIN. Described as Rochester's "scrappy, fast skating, hard checking captain" in the *Democrat & Chronicle*, winger Gordie "Hopalong" Hannigan was embraced by the local fans immediately. After center Bronco Horvath arrived following the team's initial stumble, and wing Eddie Mazur was obtained soon after, Billy Reay formed the club's three stars into what became known as Rochester's Production Line and one of the most potent scoring threats in the AHL. A never-say-die competitor, he scored two goals in Rochester's 5-4 overtime loss at Cleveland that gave the Barons their eighth Calder Cup. (Society for International Hockey Research.)

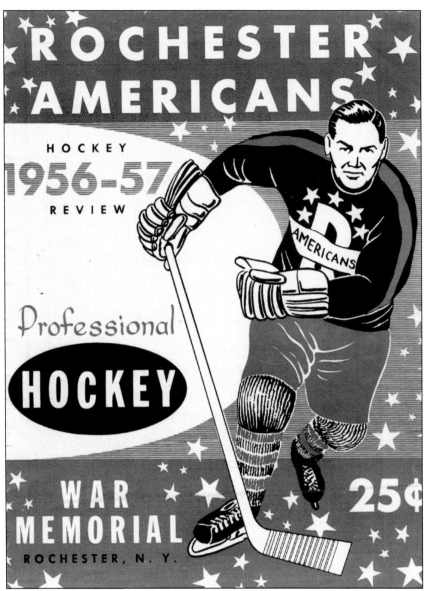

First Program Cover and the Name "Americans." This program cover from the Rochester Americans' first home game of October 14, 1956, is the same cover that was used throughout the first thrilling season. In 2003, Rochester Americans Hall of Fame member Ed House put an end to the myths and legends of how the franchise chose the nickname Americans. According to House, the Rochester Americans were named by Frank J. Selke, managing director of the Montreal Canadiens, at a meeting in Canada, not because Montreal was the Canadiens, but because there had been an NHL franchise in New York City—the New York Americans, one-time parent of the old Rochester Cardinals—that once had that name and the team had long since vanished from the professional scene. "Wouldn't that be a great nickname for you guys?" asked Selke. House's explanation carried a great deal of weight, as he was at the meeting and the results are in the uniforms, both the home (pictured) and the road, which were closely mirrored after the home and road uniforms of the New York Americans of the mid- to late 1930s.

City of Rochester, N. Y.
OFFICE OF THE MAYOR

PETER BARRY
MAYOR

October 3, 1956

Mr. Paul Bibeault, General Manager
Rochester Americans Hockey Club
Community War Memorial
Rochester 14, New York

Dear Mr. Bibeault:

 In behalf of the people of Rochester and its metropolitan area, I am delighted to welcome the advent of the Rochester Americans Hockey Club--the first team in twenty years to represent Rochester in this exciting international sport.

 It is most fitting that the Americans should join the growing family of those who use our beautiful War Memorial Auditorium. The Americans are bringing to Rochester a fine professional version of a game which many of our people enjoy. Not only will this provide the healthiest type of entertainment for the spectators but it is also another step in cementing an ever closer friendship and feeling of good will between our nation and our friends and neighbors to the north.

 Warmest greetings to the Rochester Americans and very best wishes for success in this coming twenty-first season of the American Hockey League.

Sincerely,

Peter Barry
Mayor

PB:ers

WELCOME TO ROCHESTER

MAYOR'S WELCOME. The Amerks reprinted this October 3, 1956, welcome letter from Rochester mayor Peter Barry in their first programs. Barry saw the establishment of the Americans franchise as not only the value of hockey as entertainment but as an opportunity to continue to improve the relationship between the United States and Canada through the international sport.

> # GOOD SKATING
> ## ROCHESTER AMERICANS
> ### FROM THE
> # WORLD CHAMPIONS MONTREAL CANADIENS
> #### Member of the N. H. L.

STRANGE BEDFELLOWS. The rivalry between the two NHL franchises that co-owned 55 percent of the Rochester Americans Hockey Club in its early stages can be seen even in the two congratulatory advertisements that appear not as a joint greeting from happy parents, but rather some nine pages apart in a 32-page program. This separation between the parties was reputed to have continued in the locker room, on the bus, at meals, and with lodging arrangements, not to mention after games when the Montreal front office would openly praise their talent while criticizing Toronto's prospects, and vice versa, particularly at the start of the season. Somehow, Billy Reay was able to put all of the behind-the-scenes politics to rest and develop a winner.

> The Toronto Maple Leaf Hockey Club of The National Hockey League
>
> *-Salutes-*
>
> The Rochester Americans Hockey Club of The American Hockey League
>
> and extends all good wishes to hockey fans in the Rochester area

FIRST GOAL. Winger Mickey Keating scored the very first goal for the Rochester Americans during a regular-season game in a 6-3 loss for the Amerks at Cleveland. Like Leo Lafrance with the Rochester Cardinals 20 years earlier, Keating did not score another goal for Rochester in his brief stint here. Although he never played in the NHL, he served as assistant general manager of the New York Rangers. Known for his warmth, compassion and optimism, he passed away after a courageous bout with cancer at the age of 72 on January 19, 2004. (Society of International Hockey Research.)

THE PEN IS MIGHTIER. Hans Tanner began working for the *Democrat & Chronicle* in 1950 and was assigned to the Rochester Americans hockey beat for the 1956–1957 season. Tanner's dedication was extraordinary, and he did not miss a single home game until he stopped covering the team in 1977. His collected game accounts and observations are an indispensable account from, effectively, the only man who could claim to be a team historian for the entire 20-year period. He was honored with induction into the Rochester Americans Hall of Fame in 1986.

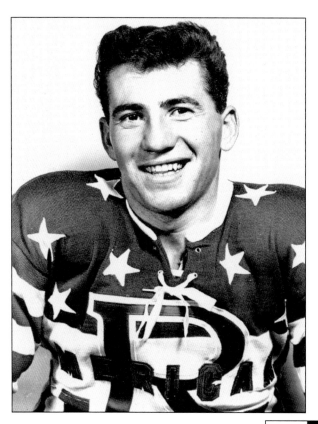

ELVIS IS IN THE BUILDING. At 11:03 in the first period on Sunday night, October 14, 1956, Mike "Elvis" Nykoluk emerged from a scramble behind the Barons' net on a power play and lifted a backhander into the mesh past goalie Marcel Paille to score the first regular-season professional goal ever at the War Memorial. One of his most important goals of the season was the game winner against Johnny Bower of Providence on March 31, 1957, in front of 7,512 fans to give the Amerks a 3-1 game lead in the best-of-seven first round of the Calder Cup playoffs. (Rochester Americans; photograph by David Bier.)

THE FIRST RULE BOOK. The AHL 1956–1957 rule book was a 60-page booklet that included six pages of a game-by-game schedule for the league's six teams: Rochester, the Buffalo Bisons, the Cleveland Barons, the Hershey Bears, the Providence Reds, and the Springfield Indians.

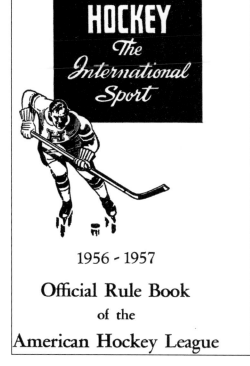

THE BRONC. Center Bronco Horvath was the Amerks' first scoring hero, riding in like an Old West hero to the rescue when the new team and its coach needed offensive leadership. Horvath, known for his belief in his own abilities, often told his teammates what he was going to do, and then did it. He spent the season terrorizing the league's goaltenders and led the club in scoring with 37 goals and 44 assists for a total of 81 points in just 56 games. Billy Reay called him "the best shot in the league . . . period." He was named a first-team all-star and claimed six game winners and two free new fedoras from Mike Harris of Warren Hats. Horvath netted the team's only two hat tricks, with the first Amerk hat trick ever coming on Kodak Night, December 9, 1956, at the War Memorial in a 6-0 shutout against Springfield. (Ernie Fitzsimmons Collection.)

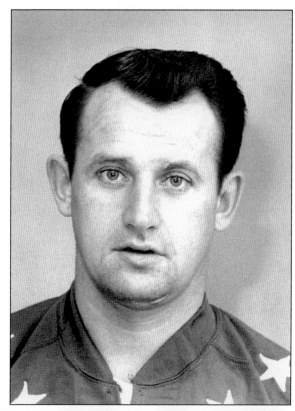

HAT TRICK
by
WARREN HATS

FREE
"STETSON" For Every American Scoring 3 Goals In One Game.

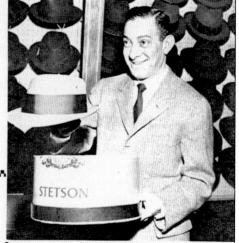

MIKE HARRIS, Proprietor
Featuring
J & M Shoes - Stetson Hats
Jarman Shoes

WARREN HATS -- 6 MAIN ST. W. IN THE POWERS BLDG
LOcust 2-8339

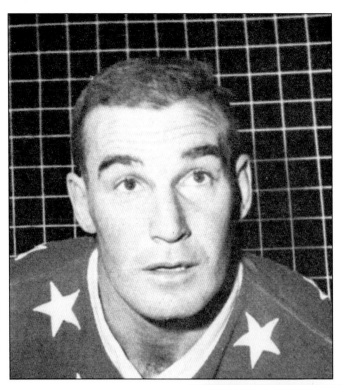

TO AND FRO. Gary Aldcorn was a left wing who spent the first three years of his professional career shuffling back and forth between the Maple Leafs and the Americans while posting respectable numbers with Toronto and impressive numbers in Rochester by his third season. As a junior, he was a member of the 1955 Memorial Cup champion Toronto Marlboros. While he scored 13 goals for the first-year Amerks, his most memorable year in Rochester was 1958–1959, when he was named a first-team all-star with 37 goals and 42 assists for 79 points in 66 games.

THE SPIDER. Ed "Spider" Mazur was a fearless, top-notch puck handler who emerged as a second-team all-star for the Amerks in the team's first year. He was a fan favorite in Rochester with all six of his game winners, including one in the playoffs, coming at home and because of his tenacity on the ice and his gracious and unassuming nature off of it. His hallway brawls between the periods with Larry Zeidel of the Hershey Bears were legendary in the early days of the War Memorial. A Stanley Cup winner with the Canadiens before his arrival, he tallied 111 points in 106 games with the Amerks.

THE OLD MAN. At the ripe age of 33, Tommy "Red" Williams was, chronologically, the "Old Man" of the 1956–1957 Amerks, but he played the season like anything but aged. Red came to Rochester with three AHL All-Star selections and three Calder Cups, all with Cleveland, and brought his outstanding puck-stealing skills with him. While he played 62 games without a goal, his value to the team was apparent to both the fans, who selected the reserved leader as their favorite Amerk, netting him a $100 savings bond, as well as the media, who again named him an all-star.

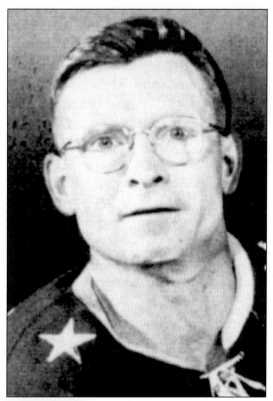

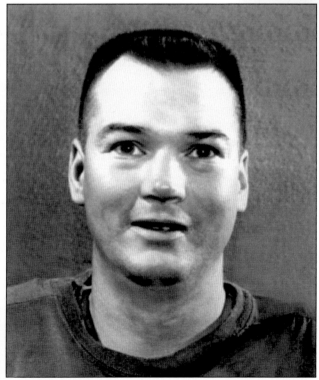

FABULOUS AB. Ab McDonald was an outstanding scorer in junior hockey who began his professional career with the 1956–1957 Amerks. Like Eddie Mazur, he had the game-winning touch at home, lighting the lamp four times at the War Memorial, including twice against Buffalo's Harry Lumley. On March 26, 1957, his goal off Johnny Bower was the lone tally in Rochester's first-ever playoff game and victory. He would go on to lead the Amerks with 30 goals in 1957–1958, capture four Stanley Cups, and play in five all-star games in his 762-game NHL career. (Society for International Hockey Research.)

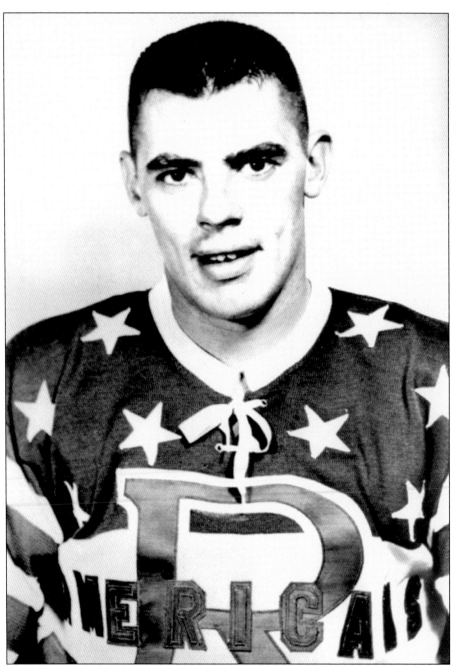

Spider No. 2. Earl "Spider" Balfour was known for his defensive abilities as a forward at the NHL level, but as a member of the first-season Amerks, he was a potent offensive threat on a team with no shortage of scorers. In fact, that year was the first time that Balfour scored 21 goals during one season in his five years as a professional. Having spent the entire 1955–1956 season with the Maple Leafs, Balfour brought a great deal of savvy and discipline to the Flower City expansion team and was a key leader in the postseason with eight points in 10 games. He was later reunited with Ab McDonald on the Chicago Blackhawks' 1960–1961 Stanley Cup champion team. (Ernie Fitzsimmons Collection.)

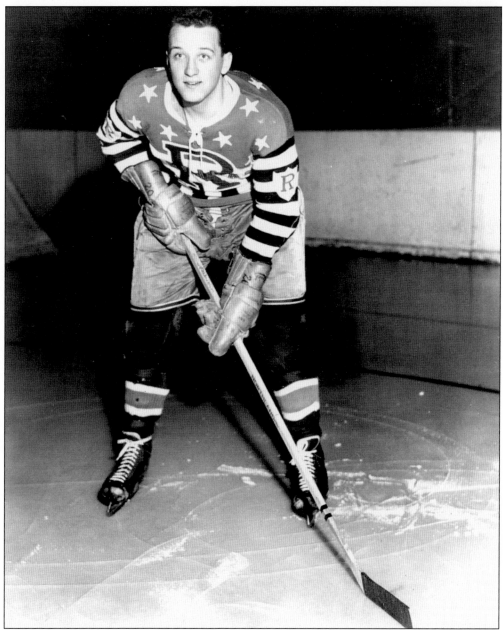

JUNIOR. Al "Junior" Langlois played 115 games for the Americans during the first two years of the franchise. A solid defenseman with good passing skills, he tallied 35 assists during his time with the Amerks in addition to 4 more in 10 postseason games. His development here served him well as he parlayed it into 497 games in the NHL, including playing in two all-star games in 1959 and 1960 and hoisting the Stanley Cup with the Montreal Canadiens at the end of both seasons. (Rochester Americans.)

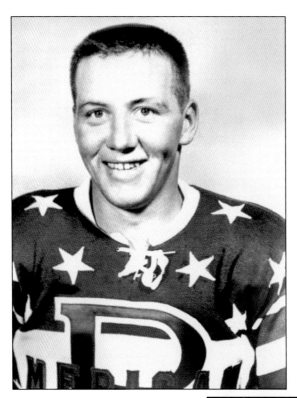

THE CAPTAIN'S BROTHER. Pat Hannigan's first full year as an Amerk was 1959–1960 as part of the Rochester "Miracle Team," who pulled off one of the greatest comebacks in hockey history by defeating Cleveland in four straight games after losing the first three. Pat scored one of the biggest goals in Rochester hockey history on that magic night of April 10, 1960, at 18:03 of the second period when he fired a riser toward the net that hit Baron goalie Gil Mayer's arm and rolled down into the mesh. Rochester went on to win the game 4-1 before 7,762 delirious fans. (Ernie Fitzsimmons Collection.)

CURTAIN. As the first captain of the Amerks, Gordie Hannigan helped define the tenacity that has often been the trademark of the gritty, determined Rochester teams. Although he scored 21 goals and 40 assists for 61 points in the 1956–1957 season, in addition to adding six points in the postseason and leading the playoffs in penalty minutes, he played only 25 more professional hockey games. A runner-up for the Calder Memorial Trophy in 1953 for best first-season performance in the NHL after his debut 17-goal performance with the Leafs, Hannigan retired at the age of 29 in 1958 and passed away at the age of 37 in 1966. (Ernie Fitzsimmons Collection.)

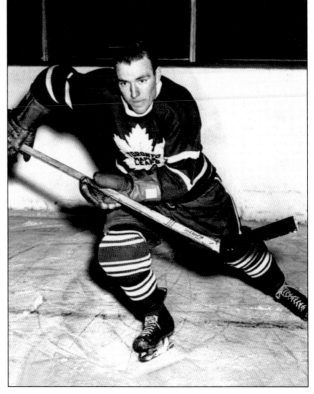

Four
BROAD STRIPES

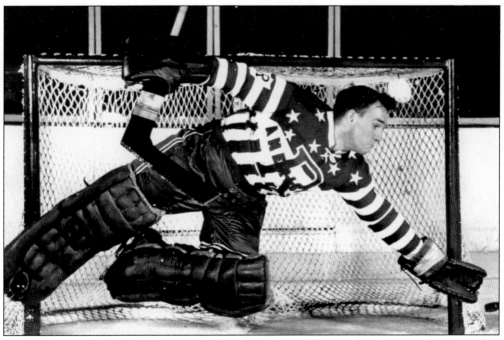

FIRST SHUTOUT. Charlie Hodge was the first Amerk, in addition to having spun the team's first shutout on November 9, 1956, against the Providence Reds 5-0 at the War Memorial before a crowd of 5,006. "It is wonderful to play in front of good crowds." He went on to compile a 17-18-5 record with a 3.22 GAA for Rochester and win two Vezina Trophies and two Stanley Cups with Montreal. (Rochester Americans; photograph by David Bier.)

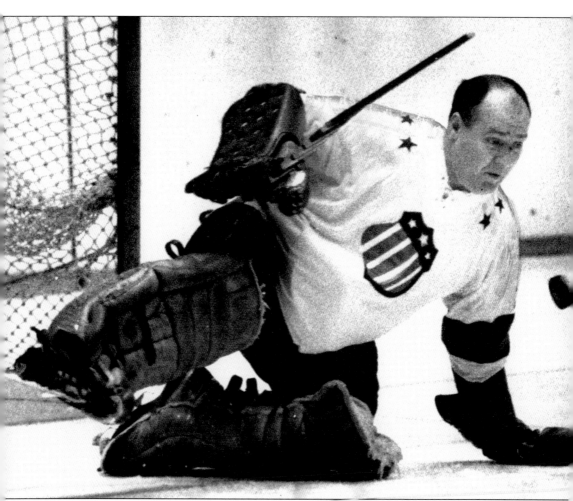

THE CAT. Cherubic, affable, and naturally dramatic in his style, especially for a peculiar affectation of removing his glove and kissing his ring after a key save, Bobby Perreault was one of the most successful and memorable goalies in the annals of minor professional hockey. In his first year in Rochester, he surged to a 16-7-0 record with three regular-season shutouts. Then, in the first playoff series, he accomplished the unthinkable by blanking the mighty Providence Reds 1-0 twice in three days to open the series, and ultimately outdueling the great Johnny Bower and downing the defending Calder Cup champs in four of five starts. The following season, he haunted Rochester with the Hershey Bears, defeating the Amerks five times before Eddie Mazur, "the man I don't want to see coming at me," rifled a shot past him for a Rochester victory. After earning two Calder Cup titles with Hershey, he later returned to play five more seasons with the Amerks, guarding the cage for Rochester's second and third Calder Cup runs. "The Cat" is Rochester's all-time goaltending leader in games played (205), shutouts (16), and playoff victories (25) and tied for the lead in playoff shutouts with Mika Noronen (6). (Rochester Americans.)

QUEBEC CITY TO THE FLOWER CITY. A teammate of Billy Reay's on the 1953 Montreal Stanley Cup champion team who played in three NHL All-Star Games, Quebec native Gerry McNeil played two full seasons with Rochester (1957–1959) and was selected as a second-team AHL All-Star in 1957–1958 with fellow Amerk Tommy Williams. His GAA in five Amerks playoff games in 1959 was a very respectable 2.40 in a 4-1 series loss to the Buffalo Bisons. (Ernie Fitzsimmons Collection.)

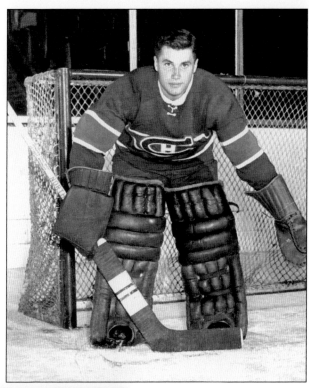

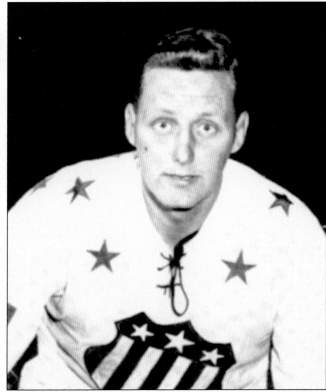

CHAD. Netminder Ed Chadwick appeared in 138 games with Rochester between the 1959–1960 and 1960–1961 seasons after winning 54 games for the Maple Leafs over a three-year span. His 39-24-4 record and 2.75 GAA led the AHL in 1960 and earned him both the Harry "Hap" Holmes Memorial Award as the league's top goalie and first-team all-star honors. His greatest contribution to Rochester hockey was his role in the Amerks' finest hour with the 1960 Miracle Team's improbable postseason comeback against Cleveland. (Rochester Americans.)

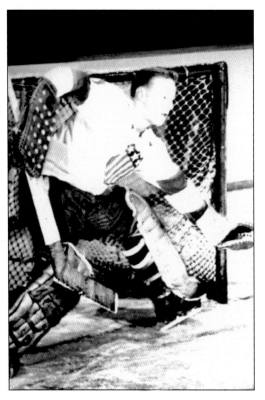

CHEESY. Gerry Cheevers holds the 40-year-old AHL record for wins in a regular season with 48 wins for the 1964–1965 season, when he appeared in all 72 games for Rochester, in addition to another 10 playoff games en route to the Amerks' first Calder Cup. When Cheevers, prior to donning his trademark painted-scar mask, struggled early in his career, Rochester coach Rudy Migay put Cheevers through extensive practice drills without his stick in an effort to get him to rely more on his pads for saves. Cheevers's career seems to have taken a new direction after that point, and he rose to new accomplishments, lowering his GAA with the Amerks from 3.95 to 2.84 in just one year. He won an astounding 86 games for Rochester from 1963 to 1965 and posted 10 shutouts in his career with the Amerks. He won Stanley Cups with the Boston Bruins in 1970 and 1972 and was inducted into the Hockey Hall of Fame in 1985 and the Rochester Americans Hall of Fame in 1986. (Rochester Americans.)

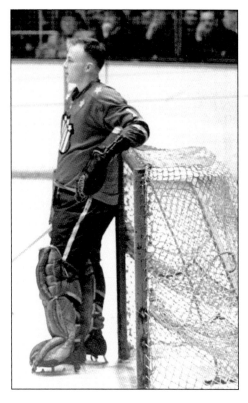

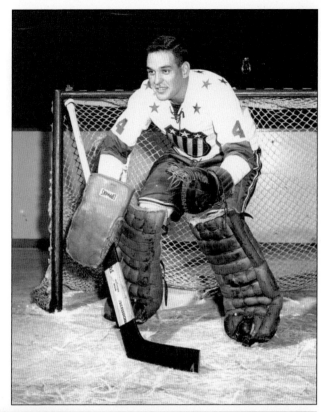

GET IN LINE, MAC. After notching his 29 wins with Cleveland in his best AHL season in 1958–1959, Gerry McNamara struggled unsuccessfully to crack the lineup of the Rochester Americans in both 1959–1960 and 1960–1961. He returned in the 1962–1963 season and appeared in 32 games for the Amerks while posting a 3.84 GAA. He is seen here in action during that year at the War Memorial, guarded by defenseman Barry Trapp as Cleveland's Hank Ciesla, a former Amerk who scored the franchise's 1,000 goal, looks on. (Rochester Americans.)

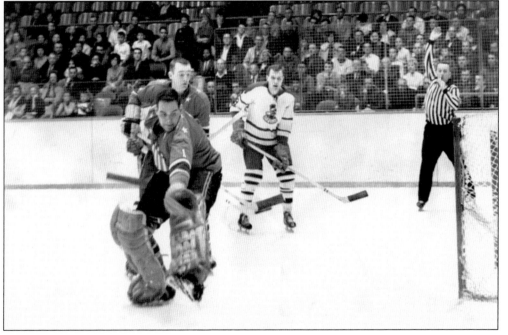

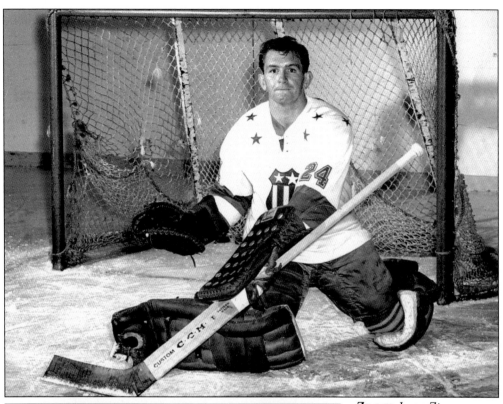

ZIMMY. Lynn Zimmerman spent six years in the Rochester crease, beginning with 13 games during the 1967–1968 Calder Cup championship season. "Zimmy," a known prankster on road trips, was one of the brighter aspects of the dark age four-year affiliation with the Vancouver Canucks and then a cornerstone of the turnaround under the legendary Don Cherry with a 27-12-7 record for the 1973–1974 Northern Division champions. His 195 games in goal with the Amerks ranks him second only to Bobby Perreault in franchise history. (Rochester Americans; Joe Giordano.)

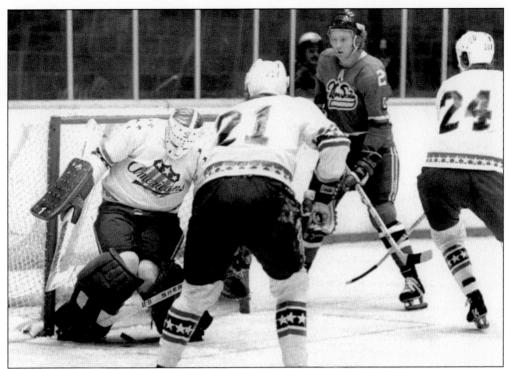

REECE IN THE CREASE. Dave Reece appeared in nearly 100 games with the Boston Braves of the AHL prior to joining the Rochester Americans during their affiliation with the Boston Bruins. In 1974–1975, he won 19 games for Dick Mattiussi's strong offensive second-place club that set what was then a team seasonal record with 317 goals and won six games for the Amerks in the playoffs, along with earning distinction as a second-team all-star. (Rochester Americans.)

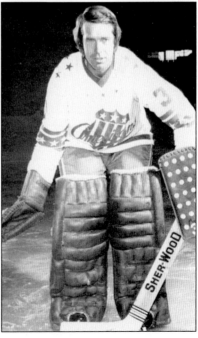

TRAVELING MAN. Bob Sneddon spent his professional career in five different minor leagues, in addition to a pit stop with the NHL's California Seals in 1970–1971. Sharing the goaltending duties with Dave Reece, he logged 65 games with Rochester from 1973 to 1975, contributing 37 victories during his stint as an Amerk. (Rochester Americans.)

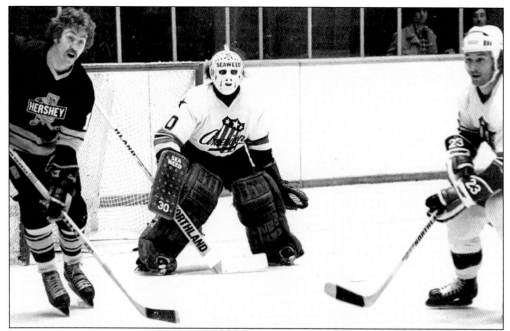

SEAWEED. Jim Pettie shuttled between the Boston Bruins and Rochester from 1976 to 1979, spending most of his time with the Amerks. The Rochester fans welcomed him immediately as he chalked up 25 victories during the regular season and another six in the playoffs during the 1976–1977 season. The exciting run fell short, four games to two, on Nova Scotia ice in the Calder Cup Finals. (Rochester Americans; action photograph by Terrence J. Brennan.)

THE MAN FROM SASKATOON. In 1977–1978, Saskatchewan's Dave Parro turned professional with the Amerks and netted second-team all-star honors with an impressive 25-16-3 record and a 2-1, 3.01 GAA in the playoffs against the New Haven Nighthawks. Overall, Parro notched two shutouts and 37 wins during his two-year assignment in Rochester and went on to backstop the Hershey Bears to five victories during their successful 1980 Calder Cup Championship drive. (Rochester Americans.)

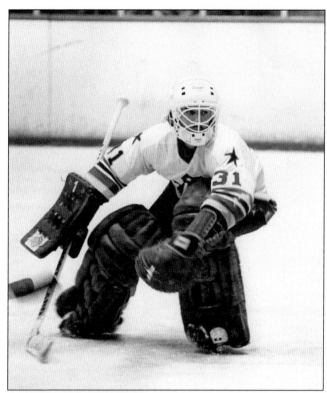

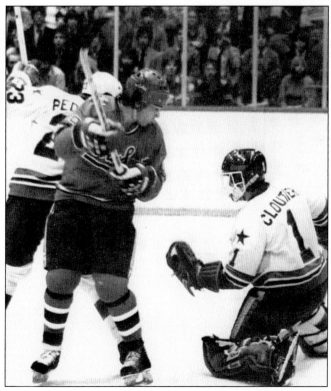

JACQUES IN THE BOX. Jacques Cloutier was, undoubtedly, one of the greatest goalies to ever sport the Amerks' red, white, and blue jerseys. He appeared in 187 games for Rochester, good for second on the all-time netminder list, totaling 96 regular-season wins, another 21 playoff victories, and leading coach Mike Keenan's 1982–1983 squad to Calder Cup immortality. With Bobby Perreault and Gerry Cheevers, he is one of three goalies in the Rochester Americans Hall of Fame. (Rochester Americans.)

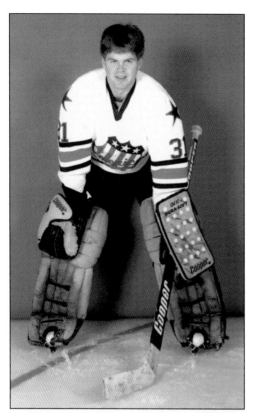

DAREN TO DO GREAT THINGS. Daren Puppa will be remembered as a popular first-team all-star who led the Amerks to their fifth Calder Cup title in 1987 and went on to play over 400 games in the NHL, primarily with the Buffalo Sabres and Tampa Bay Lightning. He won 55 games with Rochester before heading to the NHL and enjoyed his best season there with the Sabres as a second-team all-star with a 31-16-6 record and 2.89 GAA in 1989–1990. (Rochester Americans.)

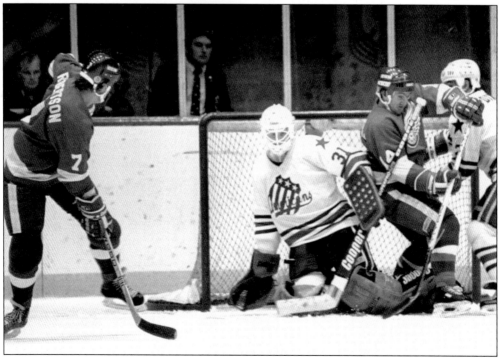

STAND UP AND BE COUNTED. Over the course of five seasons from 1986 to 1991, Darcy Wakaluk appeared in 181 games for the Amerks, tying Gerry Cheevers for fourth in franchise appearances for netminders. Reputed for his stand-up style, Wakaluk won 81 games for the Amerks while posting seven shutouts. His 21 Amerk postseason victories, including two in the successful Calder Cup run in 1987, are eclipsed only by Bobby Perreault's 25 wins, while his 17 career points are tops offensively for an Amerk goalie. (Rochester Americans.)

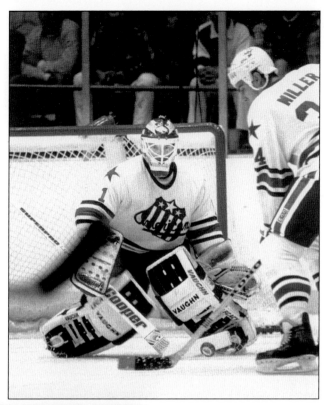

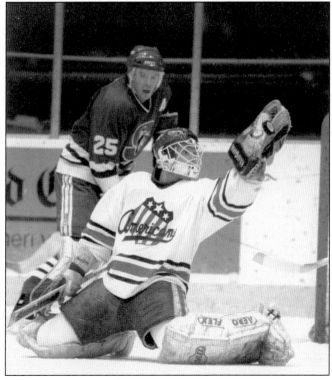

THE LITTMAN TEST. Rhode Island native David Littman played his first professional game with Rochester after a four-year collegiate run with Boston College. His greatest of three years with the Americans came in 1990–1991, when, in a first-team all-star campaign, he posted 33 victories and combined with Darcy Wakaluk to earn the AHL's Harry "Hap" Holmes Memorial Award for fewest goals allowed. He won the Holmes award again with Rochester in 1991–1992 with a 28-20-9 record, three shutouts, and a 2.95 GAA. (Rochester Americans)

GRANTED. Grant Fuhr, goaltender of the legendary Edmonton Oilers' hockey dynasty, made a brief five-game appearance with a record of 3-0-2 and a 1.94 GAA with the Rochester Americans during the 1993–1994 season. Fuhr, two-time NHL All-Star and winner of both the Vezina and William M. Jennings Trophy and over 400 NHL games, was assigned to Rochester while with the Buffalo Sabres and is a member of the Hockey Hall of Fame. (Society for International Hockey Research.)

SHIELDED FROM HARM. Mention Steve Shields and Rochester residents have fond memories of the last Calder Cup Championship in 1996. A University of Michigan two-time all-star standout, Shields completely dominated the playoffs, posting a 15-3 record and beating Portland goalie Ron Tugnutt 2-1 in the thrilling game seven final against the Pirates at the War Memorial. Of Rochester's six Calder Cups, only the first in 1965 and the last one were won on Rochester's rink. (Rochester Americans.)

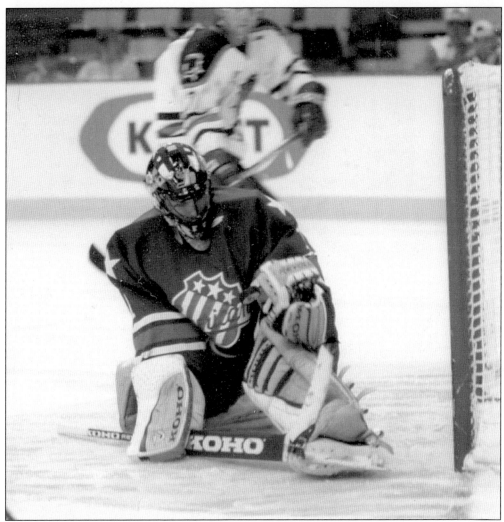

MARTY. Between 1997 and 2001, Martin Biron protected the net for Rochester in 103 regular-season games and 24 playoff appearances. In 1998–1999, he turned in an astounding 36-13-3 record, six shutouts, and a 2.07 GAA in 52 starts to lead the Amerks to one of their finest regular seasons in history with a 52-21-1-6 title for 111 points. Although the club faltered in the Calder Cup finals to the Providence Bruins, Biron captured first-team all-star accolades, the Baz Bastien Memorial Trophy as the league's leading goaltender, and shared the Harry "Hap" Holmes Memorial Trophy with teammate Tom Draper. His .921 career save percentage with the Amerks puts him in a class by himself. (Rochester Americans; photograph by 20 Toe Photo.)

MIKA. Mika Noronen's 80 wins, 15 shutouts, and 2.34 career GAA with Rochester are reasons enough to distinguish the Finnish goaltender's career with the Amerks, but his six shutouts in the 2000 Calder Cup playoff run set an AHL record for a playoff series. Noronen also posted an incredible 1.80 GAA and .935 save percentage in a postseason that came to an end in the final round against the Hartford Wolf Pack. He is a two-time AHL All-Star and was named the top AHL rookie in 2000. (Rochester Americans; photograph by 20 Toe Photo.)

THE SPARTAN. As the 2001 Hobey Baker Memorial Award winner and top collegiate player, Michigan-born Ryan Miller is regarded as one of the top goaltending prospects in the AHL. During just two years with the Amerks, he has compiled 50 regular-season wins and dominated the opposition in seven shutout victories. (Rochester Americans; photograph by 20 Toe Photo.)

Five

BRIGHT STARS

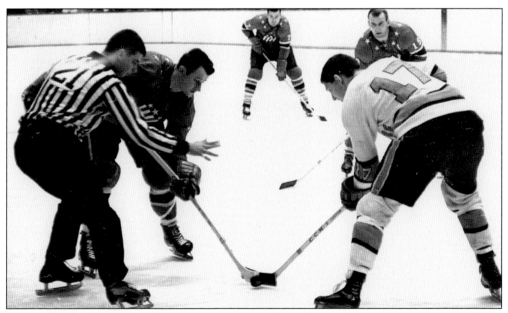

TRIPLE THREAT. The trio of Rochester Americans Hall of Famers, seen here from left to right in dark starred uniforms, are Bronco Horvath (center), Duane Rupp (defenseman), and Gerry Ehman (right wing) as they play against the Baltimore Clippers in 1964–1965 action in Rochester. Horvath finished second in AHL scoring for the season with 106 points, while Gerry Ehman placed sixth with 87 points in leading the Amerks to the first Calder Cup. (Rochester Americans.)

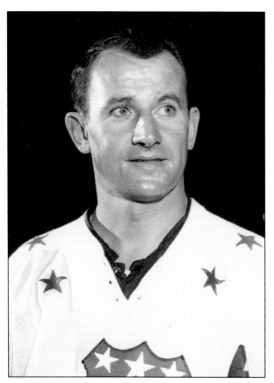

HORVATH AND HULL. Horvath was one of the premier scorers in Amerks history, ranking third in points with 542, fourth in goals with 199, and second in assists with 343. He was recognized with AHL All-Star honors three times while he was in Rochester. A veteran of over 400 NHL games, as a Boston Bruin he tied with Chicago's "Golden Jet" Bobby Hull for the NHL goal lead with 39 in 1958–1959, only to lose the Art Ross Trophy to Hull by just one assist in the final game of the season, a clash between the two rivals. (Rochester Americans.)

NYKOLUK OF THE NORTH. Toronto native Mike Nykoluk scored 23 goals and 50 assists for 73 points in 97 games for the Rochester Americans. As part of a deal that brought Willie Marshall to the Maple Leafs for the 1958–1959 season, Nykoluk was sent to Hershey, never to return to the Amerks. Fourteen years and two Calder Cups later, all spent with Bears, the "Big Bear" retired. Always willing to feed a linemate, he currently ranks sixth in AHL career points and third in AHL career assists. (Rochester Americans; photograph by David Bier.)

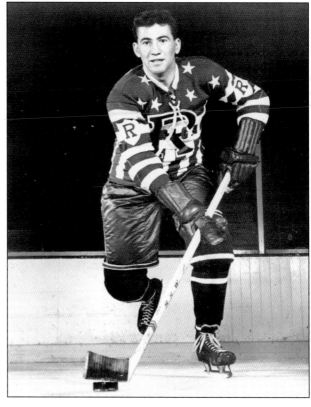

SMRKE AT WORK. A hard-checking, high-scoring left wing born in Belgrade, Rochester Americans Hall of Famer Stan Smrke was the first Yugoslavian-born player ever to play in the NHL when he played four games with the Montreal Canadiens in the 1956–1957 season. In his debut year with the Amerks in 1957–1958 in which he scored 20 goals, he became the second Amerk ever to score a hat trick on December 27, 1957, against Buffalo. He had five more seasons with 20 or more goals with the Amerks by 1967. (Rochester Americans.)

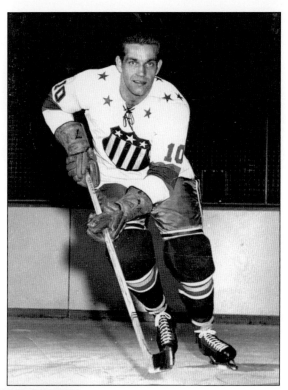

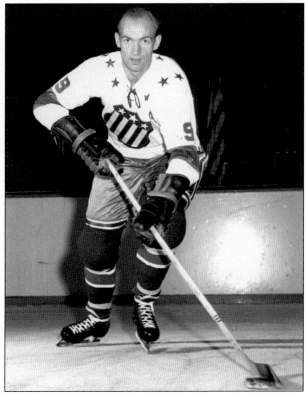

ADAM'S DAD. Dave Creighton, Rochester captain for the 1960–1961 season, had already appeared in five NHL All-Star Games and played in almost 600 NHL tilts by the time he arrived at the War Memorial in 1958. From 1959 to 1961, he scored an impressive 55 goals in two seasons with the Amerks. Nevertheless, he was traded to Buffalo at the end of the season for a Bison nemesis who became an Amerk legend—the great Dick Gamble. (Rochester Americans.)

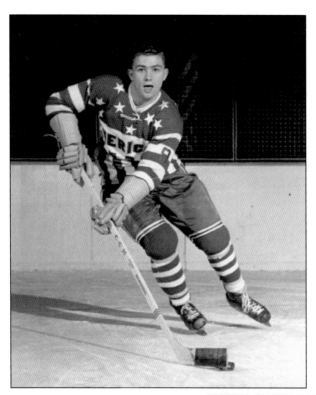

THE ROOKIE CO-MVP. Billy Hicke shattered Bronco Horvath's single-season goal-scoring mark of 37 by finishing the 1958–1959 year with 41 goals in his rookie professional year, winning the AHL's Dudley "Red" Garrett Memorial Award as the league's leading rookie. By adding 56 assists to his goal total, he finished with 97 points overall in 69 games and shared the AHL MVP Award with teammate Rudy Migay. His promising NHL career was plagued by illness, although he did log over 700 games and appeared in three all-star showcases. (Rochester Americans.)

THE VETERAN CO-MVP. The diminutive Rudy Migay played almost 400 games with the Maple Leafs and only 15 with the Amerks when joining Billy Hicke in the fall of 1958 in Rochester. His 24-goal, 58-assist season for 82 points in just 51 games earned him AHL co-MVP honors. This was the first and last time teammates shared the award in AHL history. Both he and Hicke were named to the all-star team, while Migay captained the Amerks the following year and coached them in 1962–1963. (Rochester Americans.)

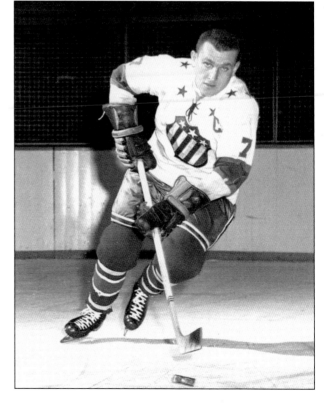

THE SCORING KING. Willie Marshall, the AHL's all-time scoring leader in goals (523) and assists (852), spent parts of two seasons in Rochester with the Amerks, first in 1958–1959 and 15 years later at the end of a brilliant AHL career in 1971–1972. He tallied 23 points in 19 games during his first tour of duty, and more than 300 goals later, he came to the Rochester team destined for the basement and tallied his last four AHL points in 10 games, then retired thanking the club for the opportunity. During the 2003–2004 season, the AHL's annual goal leader trophy was named in his honor. (Rochester Americans.)

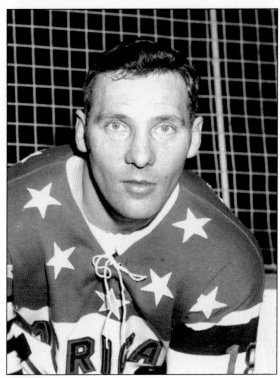

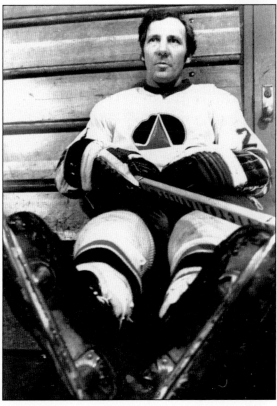

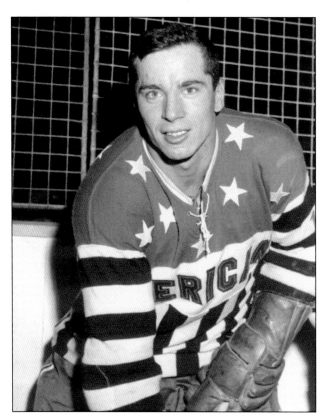

A Tragic End. Murray Balfour played just one season in an Amerks jersey, but the aggressive forward notched 14 goals and 23 assists for 37 points in 67 games, in addition to 181 penalty minutes. At the end of the year, he was sold by Montreal to the Chicago Blackhawks and became part of the Million Dollar Line with Billy Hay and Bobby Hull. He played on the Stanley Cup champion team in 1961, but due to a broken arm during the series, was not there to sip the champagne with his teammates. He passed away from cancer at the age of 28. (Rochester Americans.)

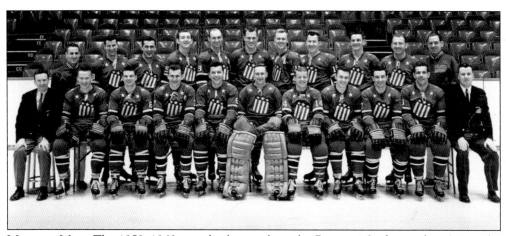

Miracle Men. The 1959–1960 comeback team beat the Barons 4-3 after trailing 3-0 in the best-of-seven playoff series. Players, from left to right, are as follows: (first row) Jack Riley (general manager), Pat Hannigan, Ted Hampson, Rudy Migay (captain), Steve Kraftcheck (player and coach), Ed Chadwick, Guy Rousseau, Billy Saunders, Dick Van Impe, Stan Smrke, and John Clapp (assistant general manager); (second row) Steve MacAdam (assistant trainer), Al MacNeil, Dick Mattiussi, Bobby Nevin, Dave Creighton, Hank Ciesla, Cecil Hoekstra, Joe Crozier, Howie Young, Claude Labrosse, and Don Smith (trainer).

THINGS WENT BETTER WITH WALLY.
Wally Boyer is the only one of 11 players in Amerks history to score 20 or more goals in four or more seasons with Rochester and not be selected for the Rochester Americans Hall of Fame. A popular center better known for his tenacity on penalty-kill units and assisting famed goal scorers like Bronco Horvath, Gerry Ehman, and Dick Gamble who frequently overshadowed him, Boyer nonetheless enjoyed five consecutive seasons in the AHL (1960–1961 through 1964–1965) in which he netted 112 goals. He spent all of those years in Rochester with the exception of 1962–1963, when he was on loan to the irascible Eddie Shore and his Springfield Indians. During the year, Shore bragged that he bet Rochester "wished they had him back" with the difficulties they had in finding an adequate center to replace him. The following year, he was back and in 1964–1965 he netted 20 goals and 41 assists in the Amerks' run for their first Calder Cup title. (Rochester Americans.)

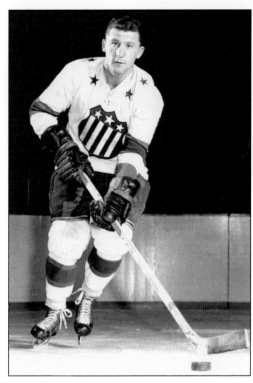

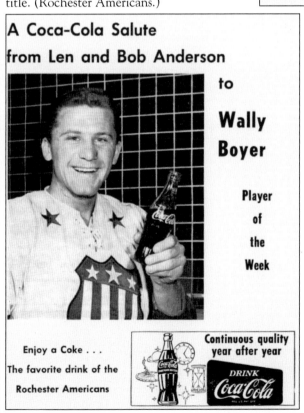

A Coca-Cola Salute from Len and Bob Anderson to Wally Boyer Player of the Week

Enjoy a Coke . . . The favorite drink of the Rochester Americans

Continuous quality year after year

DRINK Coca-Cola

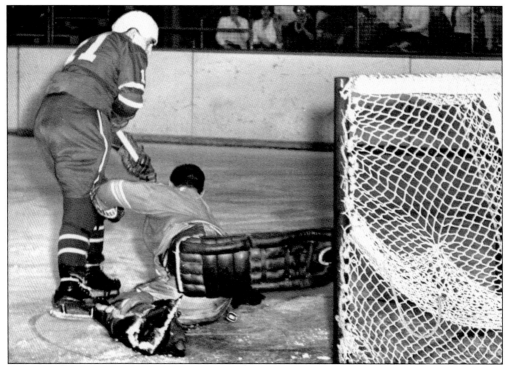

GENE ON THE SCENE. Gene Ubriaco, seen here in a rare action shot with an early model helmet, was a forward that played two solid seasons with Rochester, 1960–1961 and 1962–1963, sandwiched around a year with the Pittsburgh Hornets. His better season with the Amerks was the latter one for coach Rudy Migay when he played in all 72 regular-season battles and scored 22 goals and 48 assists for 70 points. (Rochester Americans.)

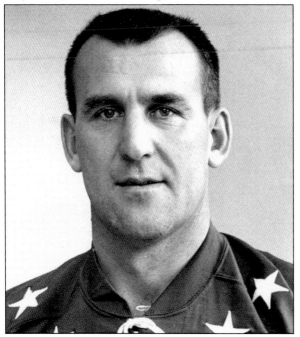

TEX. Amerk teammate Don Cherry called Gerry "Tex" Ehman "as hard as worker as you will ever see. He was a natural leader." Ehman, a member of the Rochester Americans Hall of Fame, posted 237 goals and 238 assists for Rochester from 1961 to 1967. Always reliable, he scored 30 or more goals each year with the exception of 1961–1962, when he scored 29. He was a first-team AHL All-Star selection in 1964 and 1966 and a second-team all-star in 1961. (Rochester Americans.)

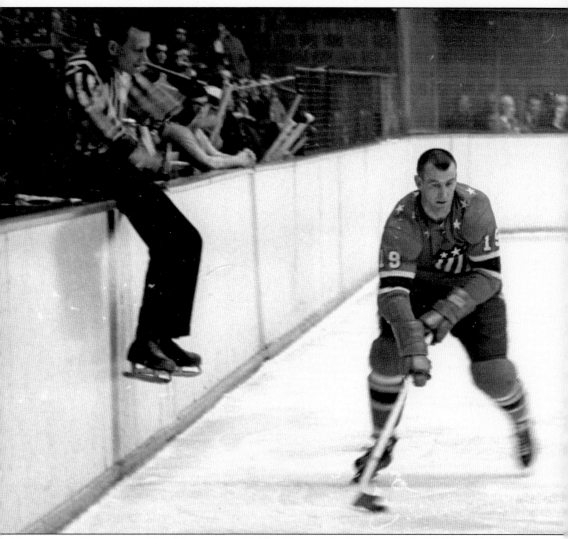

SILVERWARE COLLECTOR. Tex Ehman won Calder Cups with the Amerks in 1965 and 1966 after being called up to the Maple Leafs for the 1964 Stanley Cup playoffs by Punch Imlach and winning an NHL championship title with Toronto. Prior to that, he won the John B. Sollenberger Trophy as the AHL's top scorer for the 1963–1964 season. (Rochester Americans.)

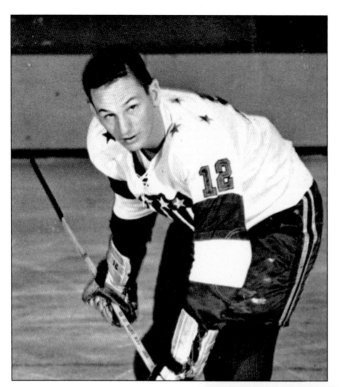

TWO FOR TWO. Jim Pappin was a naturally gifted right wing scorer who went professional with the Amerks in 1960–1961 and netted 62 goals over the following two seasons. Although he shuttled between Toronto and Rochester through the 1967–1968 season, he scored two of the most important goals in the history of the Amerks—the Calder Cup winners in 1965 and 1966. His 21 career playoff goals for Rochester are second only to Jody Gage's 36. A Rochester American Hall of Famer, he played 767 games in the NHL, scored 278 goals and played in five NHL All-Star Games. (Rochester Public Library Local History Division.)

THE OLD LAMPLIGHTER. From 1961–1962 through 1969–1970, Dick "Grumps" Gamble scored 300 goals for the Amerks and notched three seasons with 46 or more goals. After winning three Calder Cups with the Amerks, he retired as Rochester's career leader in games (569), goals (300), and points (565), eventually passed in all three categories only by Jody Gage. He later coached the Amerks from 1968 to 1971, was named a Rochester American Hall of Famer in 1986, and had his No. 9 jersey retired along with Jody Gage's No. 9 on March 19, 1999. (Rochester Public Library Local History Division.)

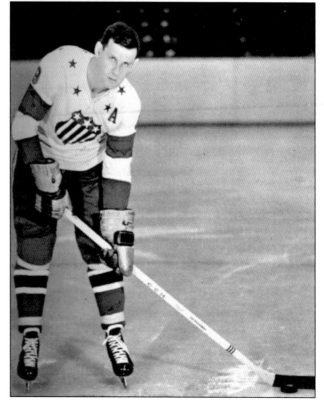

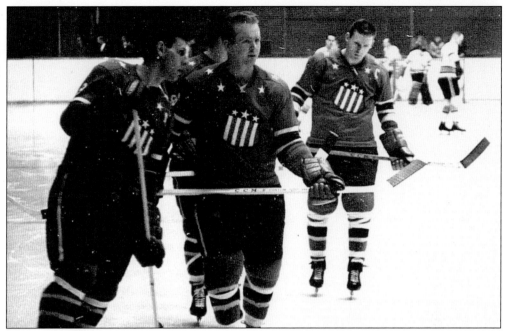

BREAK IN THE ACTION. The Rochester Americans are seen playing at the War Memorial during the 1964–1965 season against the Baltimore Clippers. Players, from left to right, are Rochester Americans Hall of Famers Dick Gamble and Red Armstrong with captain Larry Hillman. (Rochester Americans.)

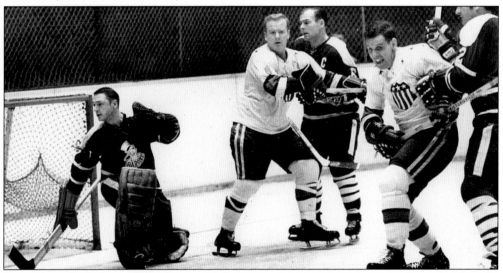

RED. Norm Red Armstrong was one of the most tenacious, aggressive, and popular Amerks players from 1962 to 1971 and in 1972–1973. Although he played only seven games with Toronto in the NHL, he distinguished himself by scoring a goal on his first shot. An inaugural Rochester Americans Hall of Famer, he ranks sixth in Rochester goals (166), seventh in points (391), and third in games played (566). His sudden death in a construction accident at the age of 35 shocked the Rochester community. His No. 6 jersey was the first Amerks jersey retired on December 20, 1974, with the banner raised on October 11, 1985. (Rochester Americans; photograph by Glenn R. Showalter.)

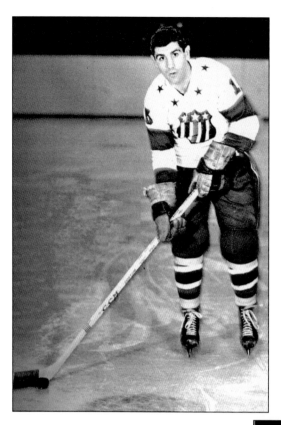

THE ENGINEER. An energetic, determined skater, Lou Angotti played collegiate hockey with the Michigan Tech Huskies and earned two NCAA Championship Tournament MVPs in 1960 and 1962 prior to joining the professional ranks with Rochester with Rudy Migay's 1962–1963 team. Angotti played 99 games in the Flower City over the next two seasons, scoring 31 goals and 45 assists for 76 points before graduating to a full season with the New York Rangers in 1964–1965. He went on to appear in over 650 NHL games. (Rochester Americans.)

RUDY THE HERO. On April 10, 1960, in Game 7 at the War Memorial, captain Rudy Migay scored the third Rochester goal of the evening 7:56 into the third period to ice the series, as Rochester's own Miracle Team completed the greatest comeback in AHL history with a 4-1 victory. Migay, who had borrowed two sticks from the Barons at the Cleveland Arena in Game 6 the previous night, put two sticks aside for safekeeping and laughed, "I scored my last two goals with Cleveland sticks." (Rochester Americans.)

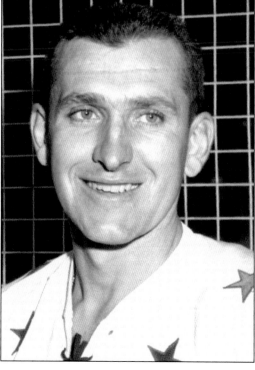

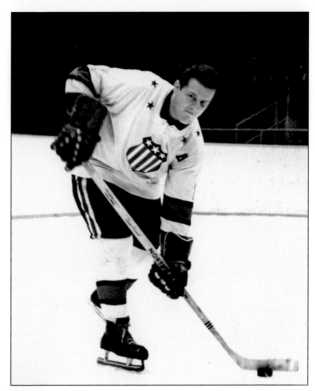

DUFF DOES IT. A member of the Rochester Americans Hall of Fame class of 1998, Les Duff was a key gritty left winger who toiled as a left wing with Rochester from 1963 to 1970. A member of all three of Joe Crozier's Calder Cup champion teams, Duff played 399 games for the Americans and ranks 10th in AHL history in games played with 927. He was best known for his penalty-killing abilities and was frequently paired with Wally Boyer for that purpose. (Rochester Americans.)

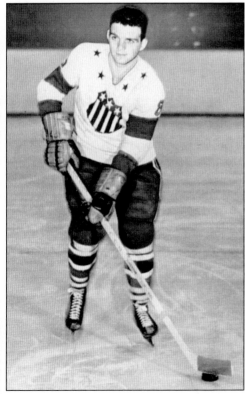

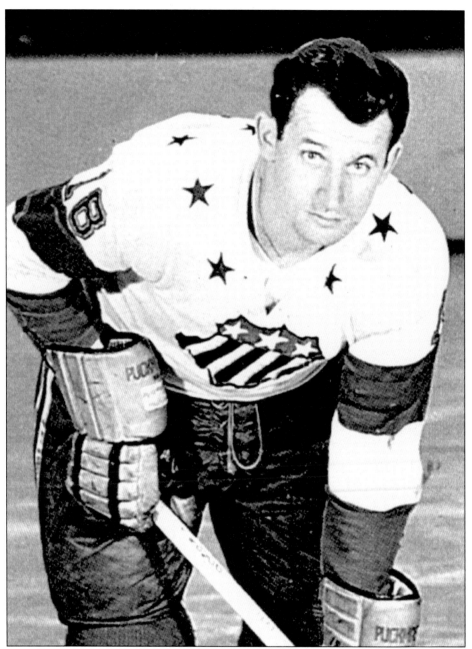

BRONCO PLAYS THE UKE. Between his visits to Rochester, Bronco Horvath enjoyed some of his greatest success as a member of the famed Uke line of the Boston Bruins with Johnny Bucyk and Vic Stasiuk. In 1957–1958, the Uke line earned its nickname from the Hungarian ancestry of its members. When the Uke line scored a combined 174 points that year, it was Bronco who led the way with 30 goals and 36 assists for 66 points. In 12 playoff games through the Stanley Cup finals, Bronco tallied five more goals, although the Bruins ultimately fell to Montreal. Horvath put up some of the most impressive NHL numbers of Amerk alumni with 141 goals and 326 points in his 434 career senior circuit games, in addition to 12 goals in 36 NHL playoff encounters. (Rochester Americans.)

HIS CUP RUNNETH OVER. Ed Litzenberger was an NHL veteran forward of six all-star games and three Stanley Cup titles, including two with Toronto, before he put blade to Rochester ice. He played two seasons with the Amerks, enjoying his better year in the 1964–1965 Calder Cup campaign when he scored 25 goals and 61 assists for 86 points while appearing in all 72 regular-season games.

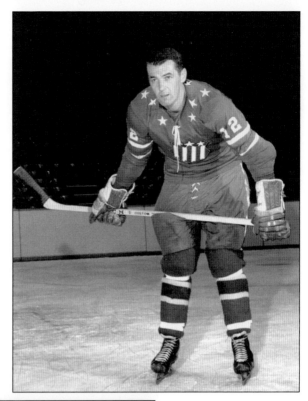

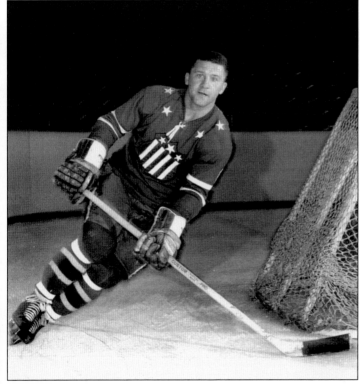

BOYER'S BACK. Wally Boyer returned to the Amerks in 1963 and posted back-to-back 20-goal seasons. Former teammate Don Cherry once stated that "Boyer was a tough little guy who did all the little things you have to do to win." One-time general manager Jack Riley said the Americans counted on "Wally to kill 85 percent of their penalties," which makes his 211 points in 278 games with Rochester even more impressive. (Rochester Americans.)

I Am Third. Ehman ranks near the top in virtually all Rochester offensive categories, but most impressively, his 237 goals and 283 assists for 520 points rank him third in each category. After his stint with Rochester, he was able, like many Amerks, to benefit greatly from the NHL's expansion. (Rochester Americans.)

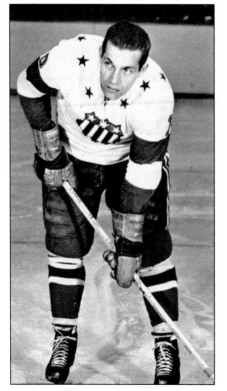

Stan the Man. Along with Jody Gage, Dick Gamble, Red Armstrong, and Darryl Sly, Stan Smrke is the only other Amerk in the team's history to appear in over 500 games. He scored 197 goals and 239 assists during his years with Rochester, good for fifth on the all-time overall scoring chart. After he died of cancer at the age of 49 in 1977, Don Cherry commented that "Stan would be a $100,000 player today" and "score 30 goals every season while the guys he was checking would be lucky to get 10." (Rochester Public Library Local History Division.)

ALL IN THE FAMILY. Bryan Hextall Jr., son of the Hockey Hall of Famer who starred with the New York Rangers, learned to skate on Madison Square Garden ice. He played just one year with Rochester but helped lead the Amerks and Joe Crozier to their third Calder Cup in four years in 1968. He was second on the team in scoring with 24 goals and 71 points while appearing in all 72 games in 1967–1968, and he added 14 points in 11 playoff games. (Rochester Americans.)

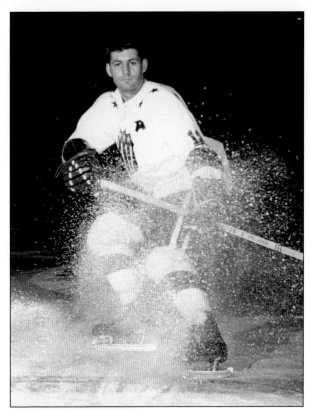

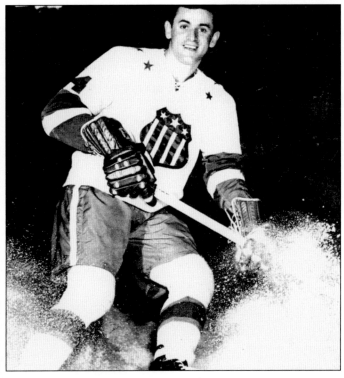

CONN SMYTHE'S SON-IN-LAW. In 1965–1966, Mike Walton was one of the offensive terrors of the AHL in his first full season with Rochester, firing 35 pucks into the mesh and adding 51 assists for 86 points in only 68 games. He was also a buzz saw in the Calder Cup playoffs at the end of the year, leading the Amerks to a Calder Cup by scoring 8 goals and 4 assists for 12 points in 12 games. He enjoyed a lengthy NHL and WHA career through 1978–1979. (Rochester Public Library Local History Division.)

THE DUKE. Duke Harris also saw his first action with Rochester in 1967–1968 and played in 38 games en route to the Calder Cup, scoring 37 points and adding 5 points in 10 postseason match-ups. After spending two years in the WHL with Vancouver, he was back with the Amerks for 1970–1972 and contributed 57 goals and 115 points for two last-place finishers. (Rochester Americans.)

HATS OFF TO BARRY. Barry Merrell, the 1990 Rochester Americans Hall of Fame selection, played for the Americans from 1972 to 1977, leading the team with 32 goals in his first year and sharing the goal lead with Doug Gibson in 1974–1975 at 44 goals. In his second and fourth seasons, he notched another 28 goals in each year. He now ranks 10th in all-time points for Rochester with 321. (Joe Giordano.)

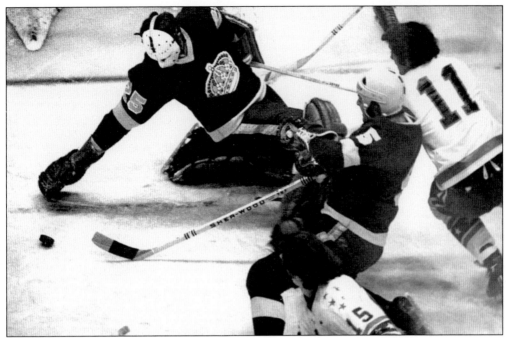

BATTLESHIP. Bob "Battleship" Kelly was the core member of Don Cherry's rebuilding of the Rochester franchise in his lone season of 1972–1973. Cherry once recalled, "Kelly would keep the goons off our backs. I have seen him challenge the entire bench of opposing teams, and nobody has budged yet." The fan favorite scored 27 goals while punching his way to 206 penalty minutes. (Rochester Americans; photograph by Jay Leiter.)

BABE RUTH ON SKATES. Art Stratton was sometimes called the Babe Ruth of minor league hockey, certainly not for his size, but rather his scoring impact on a game. Like Battleship Kelly, he played just one year with the Amerks (1973–1974) but captured all-star honors and his second AHL MVP trophy with a 24-goal, 71-assist performance. He is fifth in the AHL in all-time assists with 555. (Rochester Americans.)

INSPIRATION FOR OGIE? John Wensink was an honest-to-goodness, real life Ogie Oglethorpe, the famed character with the Syracuse Bulldogs in the hockey cult classic *Slapshot*. He looked like him, he fought like him, and he may have been tougher than him. His 284 penalty minutes in just 85 games with Rochester will never be forgotten by fans who saw him play. His best NHL season came with the Boston Bruins in 1978–1979, when he scored a career-high 28 goals. (Rochester Americans.)

TWO OUT OF THREE. Center Doug Gibson of the Boston Bruins' affiliation era captured two AHL MVP Awards for Rochester in 1975 and 1977, in addition to the John B. Sollenberger Trophy as the league's leading scorer for the 1974–1975 season. Gibson, a 1989 inductee into the Rochester American Hall of Fame, ranks 19th in franchise scoring with 96 goals and 244 points in just 170 games and merited first-team AHL All-Star honors in both MVP seasons. (Rochester Americans.)

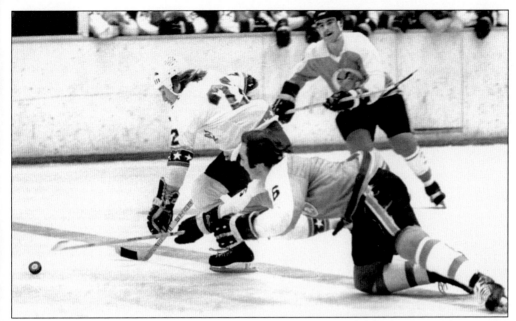

RAGIN' RON. Ron Garwasiuk was a feisty dynamo at left wing for Rochester from 1974 to 1980. The lone member of the Rochester Americans Hall of Fame's class of 1992, he scored 36 goals for Rochester in his first season with the team, was a second-team all-star for 1976–1977, and ranks 13th in franchise goals with 130 and 12th in points with 308. (Rochester Americans.)

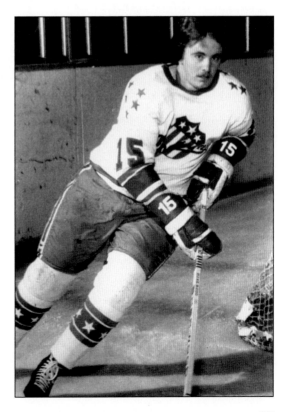

CLARK'S SPARK. Scottish-born Gordie Clark, a student of the University of New Hampshire's hockey program, thrived offensively in Rochester, scoring 123 goals and 302 points during four years with the Amerks. As a teammate of Doug Gibson's, it is fitting that he and Gibson were inducted into the Rochester Americans Hall of Fame the same year. Clark was named a second-team all-star for the 1975–1976 and 1976–1977 seasons. (Rochester Americans.)

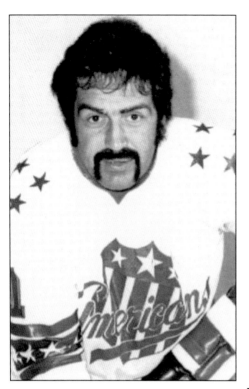

ALL THE WAY WITH RENE. A native of Quebec City, Rene Drolet played for the Amerks from 1975 to 1978. In his three seasons in Rochester, he logged 224 games for the Red, White and Blue and averaged 25 goals per season. He was a pure goal scorer, and his abilities were well known to Rochester fans before he came to the Flower City from his high-flying days of lighting the lamp with the Quebec Aces and Richmond Robins. (Rochester Americans.)

THE FIRST "MR. AMERK." Geordie Robertson was one of the most popular scoring threats in Rochester's history and known as "Mr. Amerk" before Jody Gage. A Rochester Americans Hall of Famer, he spent nearly seven seasons with Rochester from 1979 to 1985 and in 1988–1989. His most memorable season was 1982–1983, when he set the Rochester overall scoring record for a season with 46 goals and 119 points and was a cornerstone of the fourth Calder Cup championship. (Photograph by Joe Territo.)

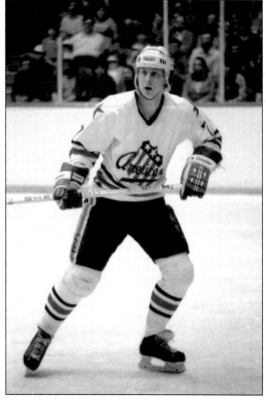

WHEN BOB WAS BOSS. Center Bob Mongrain sported an Americans jersey from 1978 to 1984. Always a prolific scoring threat, he led the team with 37 goals in 1981–1982 and broke the 40-goal barrier in 1983–1984 with 41 lamplighters. He captained Rochester to the 1983 Calder Cup title, scoring 3 goals and 8 points in 16 games, and ranks ninth in franchise goals with 153. Mongrain was inducted into the Rochester Americans Hall of Fame in 2002. (Rochester Americans.)

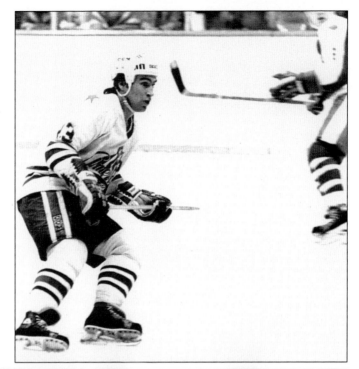

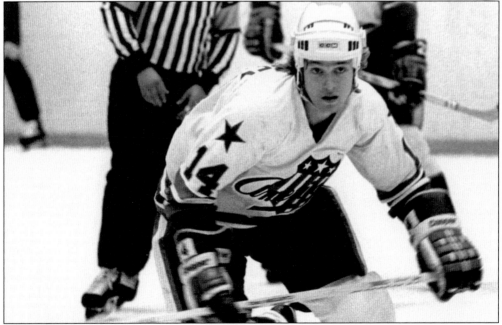

THE OLYMPIC GOLD MEDALIST. Eric Strobel was one of three members of the legendary 1980 U.S. Olympic gold medal "Miracle on Ice" team to play for the Rochester Americans. In the 1979–1980 season, Strobel netted four goals and eight points in 13 games, along with two more goals in three postseason games, the only professional games of his career. Teammate John Harrington scored 7 points in 12 games. Rob McClanahan joined the Amerks for 18 games the following year, contributing an impressive 9 goals and 22 points in 21 games. (Rochester Americans.)

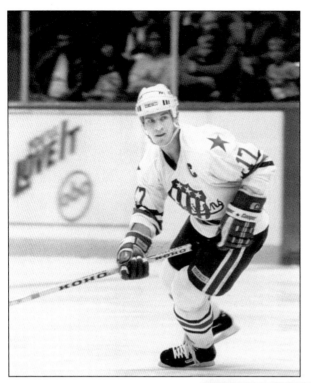

MAL CONTENT. A 2000 Rochester Americans Hall of Fame inductee, Mal Davis scored 155 goals in his 247 games with Rochester from 1981 to 1986. Davis, a right wing with a deadly wrist shot, scored 75 goals with the Amerks in his first two seasons and helped the team to a Calder Cup with a 15-point performance in 15 postseason games in the 1983 Calder Cup finals. The following year, he led the team with 55 goals and 103 points in an AHL MVP, first-team all-star season to break Murray Kuntz's 1973–1974 single-season Rochester record of 51 goals. (Rochester Americans.)

RANDY. Randy Cunneyworth played four full seasons with the Amerks from 1981–1982 through 1984–1985 after 20 games with the Buffalo Sabres. During the 1982–1983 Calder Cup championship season, he netted 23 goals and a dramatic 111 penalty minutes in 78 games. His 30 goals and 68 points in 1984–1985 led to his return to the NHL, where he scored 101 goals over the next four seasons with the Pittsburgh Penguins. He returned to the Amerks from 1998 to 2000 at the end of his 866-game NHL career and has coached the Amerks to 146 wins since 2000, the third most wins in franchise history for a head coach. (Rochester Americans.)

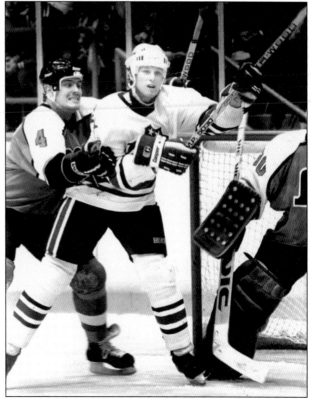

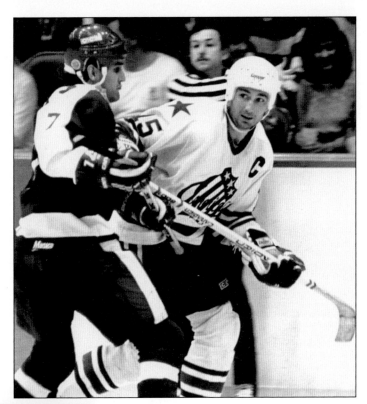

CAPTAIN FROM QUEBEC. Montreal native Chris Langevin was a popular left wing and was the member of the 1983 Calder Cup champions who was named captain of the 1984–1985 Amerks. He appeared in 208 games over four seasons for Rochester, scoring 51 goals and 116 points. Unfortunately, his NHL career was cut short by a knee injury sustained against the Quebec Nordiques on November 22, 1985, and he retired the following year. (Rochester Americans.)

KID CLAUDE. In 1983–1984, Amerk Claude Verret rose to the upper echelon of the AHL scoring ranks in his first year in the league, tallying 39 goals and 90 points in 65 games to snare the Dudley "Red" Garrett Memorial Trophy as the circuit's top rookie. He hit 40 goals the following year, good for the Rochester team lead. After the 1986–1987 season, he headed for Europe and played out his career through 2000 in France and Switzerland. (Rochester Americans.)

Sixty-One. Center Paul Gardner played just one season with Rochester in 1985–1986 after scoring 201 NHL goals, including four seasons of 30 or more with the Colorado Rockies and Pittsburgh Penguins. But Paul's season in Rochester was spectacular as the sniper ripped 61 pucks into the mesh to shatter Mal Davis's 1983–1984 single-season goal record (55) with a team that did not make the playoffs—a record that stands today. Jody Gage nearly equaled Gardner's mark in 1987–1988 with his career-high 60-goal season. (Rochester Americans.)

Gates. Gaetano "Gates" Orlando was a Providence College alumnus who thrilled his Rochester audience for five seasons from 1983 to 1988, but no thrill was greater for his fans that the game-winning goal that brought the Amerks their fifth Calder Cup on the evening of May 23, 1987, in Nova Scotia. Gates also led all Amerks scorers in that postseason with nine goals and 22 points in 18 contests. (Rochester Americans.)

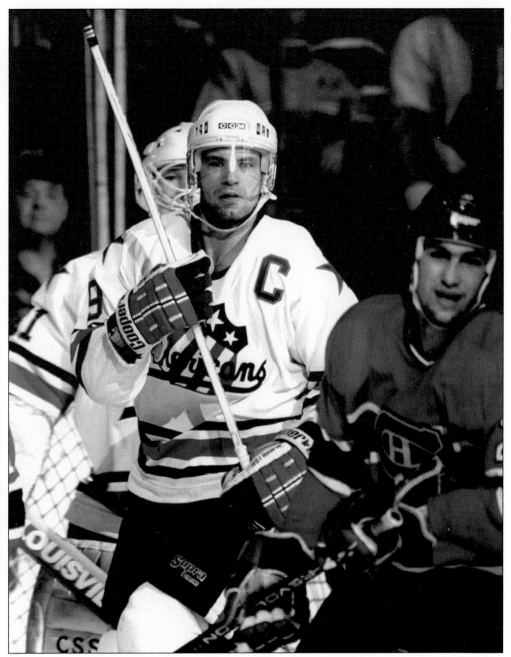

THE TOP OF THE HEAP. Jody Gage sits atop the offensive scoring charts of virtually every Amerks category, along with being the third in goals and points and sixth in assists in AHL history. A three-time AHL first-team All-Star selection and an AHL MVP in 1988, Gage, now the team's general manager, had 40 or more goals in a season six times in Rochester. Dick Gamble is second on the franchise list with three. Former teammate Richie Dunn has called Gage "the Wayne Gretzky of the AHL," an apt description. (Rochester Americans.)

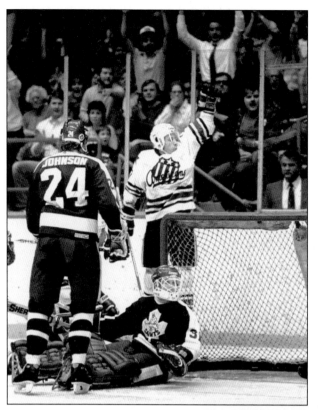

AND SPEAKING OF "THE GREAT ONE." Keith Gretzky, brother of "the Great One," spent parts of two seasons with Rochester from 1987 to 1989. He scored 11 goals—including this one—for Rochester and 48 points in 66 games but never reached the NHL. (Rochester Americans.)

SCOTTY. Scott Metcalfe joined the Amerks during 1987–1988, notching 2 goals and 15 points in 22 games. The following year, however, he established his popular style of play and enjoyed a 20-goal, 241-penalty minute performance in 60 games. After scoring 29 more goals for Rochester from 1989 to 1991, he headed for Europe and returned to the Amerks for 1993–1998, winning a Calder Cup in 1996 and having his finest year with 32 goals, 70 points, and 205 penalty minutes in 1996–1997. He is Rochester's all-time penalty leader with 1,424 minutes. (Rochester Americans.)

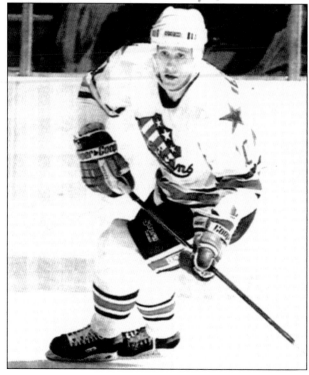

Dan Working. With his 273-game NHL career behind him, right wing Dan Frawley arrived in Rochester for the 1990–1991 season and spent three full years with the team, scoring 60 goals during the period and retiring. He returned to the Amerks in 1995–1996, helped them win their sixth Calder Cup, and spent two more years with them before hanging up the skates again. His 46 playoff points and 1,060 penalty minutes are both third in all-time Amerks records. (Rochester Americans.)

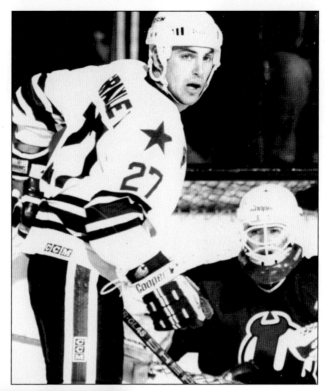

Five of a Kind. Donald Audette had an outstanding all-star year, scoring 42 goals and 88 points in 70 games in his first professional season, 1989–1990, with Rochester. He became the fifth Amerk in history to win the Dudley "Red" Garrett Memorial Award as the AHL's best rookie for his efforts, which included setting a Rochester goal record on October 29, 1989, of five goals in one game. The record, which was set in a 10-3 rout of the Binghamton Whalers at the War Memorial, still stands to this day. (Rochester Americans.)

JIM CRAIG'S NEPHEW. Craig Charron, who ranks 11th in Amerks points with 311, averaged nearly a point a game in 335 battles over five seasons in Rochester from 1995 to 1998 and from 2000 to 2002. He was a prolific scorer, particularly in his first three years, and set the tone with a 43-goal, 95-point debut during the 1995–1996 Calder Cup winning campaign, leading the team in both goals and overall scoring. As a 12-year-old, he watched from Lake Placid stands as his uncle Jim Craig's spectacular play in goal led the United States to victory over the Soviets in the 1980 "Miracle on Ice." (Rochester Americans; photograph by 20 Toe Photo.)

WE'LL TAKE YAKE. Terry Yake has enjoyed a lengthy professional career with over 400 games in the NHL. The Amerks were fortunate enough to have his services for 78 games during the 1996–1997 season, when he led Rochester in goals with 34 and overall scoring with 101 points. He enjoyed an outstanding postseason as well, scoring eight goals and 8 assists in 10 games. (Rochester Americans.)

WARDING OFF THE ENEMY. Like Yake, Dixon Ward played only one season with the Amerks, but it was a memorable one. Ward was second only to Craig Charron in team scoring with 38 goals and 94 points on the year, but he led the team in postseason scoring to the Calder Cup title with 35 points in 19 games—an all-time Amerk playoff record. (Rochester Americans.)

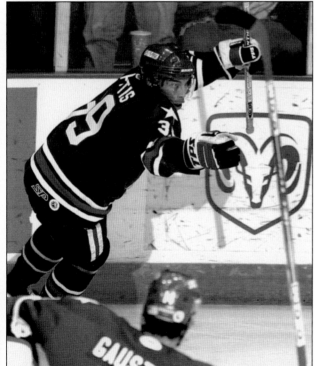

DOMENIC. Calgary native Domenic Pittis has left an indelible mark on the Amerks' history with his fine scoring skills and outstanding leadership. In 1998–1999, his first season in Rochester, he won the John B. Sollenberger Trophy as the AHL's leading scorer with 38 goals and 104 points with a 24 plus-minus rating. During 2003–2004, in his second Rochester tour of duty, he captained the team to the Calder Cup semifinals with 20 goals and 77 points. He is second in Amerks all-time playoff points to Jody Gage. (Rochester Americans; photograph by 20 Toe Photo.)

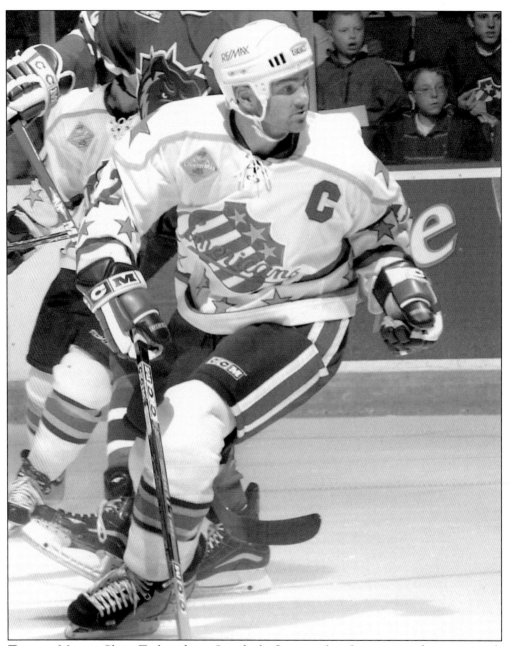

TAYLOR MADE. Chris Taylor, from Stratford, Ontario, has been a steady center with Rochester since the 1999–2000 season and has distinguished himself with three seasons of 20 or more goals. While with the Amerks, he has shuttled between Rochester and Buffalo, playing in 256 games with the Americans and 90 with the Sabres. His 170 assists with the Amerks tie him for 17th with Don McSween among all-time leaders. (Rochester Americans; photograph by 20 Toe Photo.)

Norm. Norm Milley has played for Rochester from 2000 to 2004, including two 20-goal years and 74 goals overall during that period. Milley made AHL and Rochester history with his stunning play, netting the game winners in both Games 6 and 7 against Syracuse in the first round of the 2003–2004 playoffs, completing just the 12th time in AHL history when a club has come back from a 3-1 deficit to win a playoff series. Rochester is now the only franchise ever to accomplish the feat on three occasions. (Rochester Americans; photograph by 20 Toe Photo.)

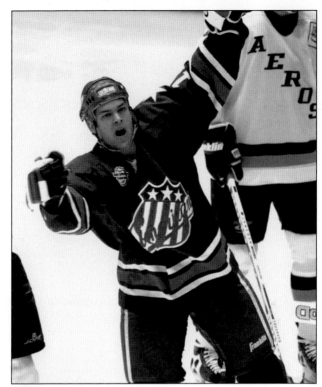

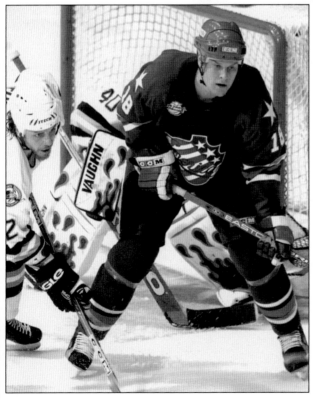

Botts. Jason Botterill, three-time gold medal winner on Canada's World Junior teams, was a high-powered forward during his four years at the University of Michigan, scoring 103 goals. In 2001, he helped the St. John Flames win a Calder Cup. His 37 goals for Rochester in 2002–2003, his first year with the Amerks, were the second best in the AHL. (Rochester Americans; photograph by 20 Toe Photo.)

MR. POWER PLAY. AHL All-Star Jason Pominville emerged as one of the top snipers in the league in 2003–2004 with 64 points in 66 games and a team-leading 34 goals, with 22 on the power play and four game winners. The Quebec native has netted 47 goals since he joined Rochester for the 2002–2003 season. (Rochester Americans; photograph by 20 Toe Photo.)

ROOKIE ROY. AHL All-Star rookie Derek Roy demonstrated outstanding promise as he split the season between Rochester and Buffalo. The energetic sharpshooter scored 10 goals and 26 points in just 26 games with the Amerks with a .149 shooting percentage. With the Sabres, he compiled nine goals, with four of them game winners, and 19 points in 49 games. He was the MVP of the 2003 Memorial Cup Championship. (Rochester Americans; photograph by 20 Toe Photo.)

Six

THE PERILOUS FIGHT

THE PRICE OF GLORY. Rochester defenseman Noel Price crashes into Buffalo Bison goalie and future Hockey Hall of Famer Harry Lumley in a 6-4 Rochester victory on October 15, 1957, at the War Memorial. (Rochester Americans.)

WOIT IN THE THICK OF IT. A solid performer with good checking skills, Benny Woit came to Rochester for the Amerks' first two seasons, bearing three Stanley Cups from Detroit. While he was a resident of Greece, he captained the 1957–1958 squad and played 99 games for Rochester, scoring 6 goals and 25 points with 94 penalty minutes. (Society for International Hockey Research.)

NOVA SCOTIA'S OWN. Al MacNeil played 185 games for Rochester from 1956 to 1960 while he was not in a Maple Leaf uniform. Although he scored only 11 goals, he added 51 assists during that time frame, and he eventually earned a regular roster spot back in the NHL with the Chicago Blackhawks. He played over 500 games in the senior circuit and coached Nova Scotia to back to back Calder Cup victories in 1976 and 1977.

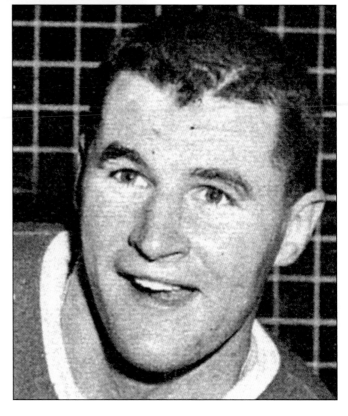

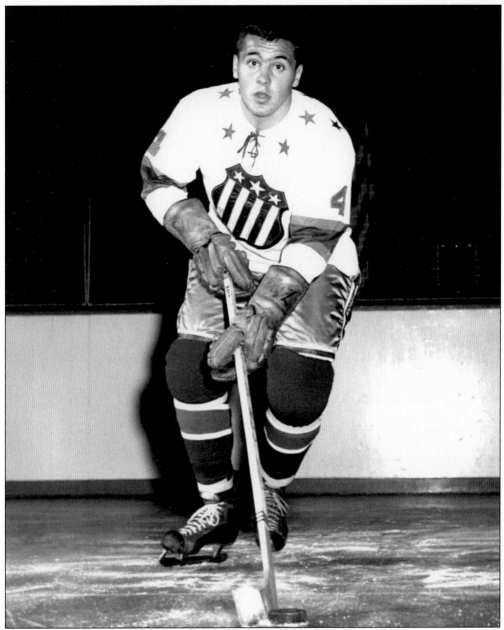

BLACKIE CARBON. Defenseman Dick Mattiussi was nicknamed "Blackie Carbon" in camp when he went professional with the Americans in 1959. From 1959 to 1961, he played 133 games while racking up 217 penalty minutes. He played over 500 AHL games and 200 NHL contests before returning to Rochester for the 1973–1974 season and scoring 38 points in 76 games. When Don Cherry was named head coach of the Boston Bruins, Mattiussi took over as head coach in Rochester and rented Cherry's house in Rochester while Cherry and his family were in Boston. Mattiussi had two fine seasons coaching the Amerks from 1974 to 1976, posting identical regular-season records each campaign of 42-25-9 for 93 points with clubs buoyed by the scoring talents of Rochester Americans Hall of Famers Doug Gibson, Gordie Clark, Barry Merrell, and Ron Garwasiuk. (Rochester Americans.)

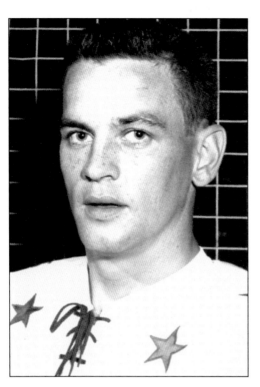

THE BAD BOY. One of the most noted and publicized aggressors of his era in the world of hockey, Howie Young began his professional career with the Amerks, playing just the regular season in Rochester in 1959–1960. He played 68 games in an Americans uniform, racking up 170 penalty minutes while adding 7 goals and 14 points. He played over 300 games in the NHL, primarily with the Detroit Red Wings, where he was labeled as the league's bad boy. (Rochester Americans.)

REGGIE. Reg Fleming was one of the early promising defensive prospects who began their professional careers in Rochester. In the 1958–1959 season, the gritty rookie appeared in 70 games, tallying 112 penalty minutes and 6 goals with 22 points. He won a Stanley Cup in 1961 as an NHL rookie with Chicago, and after a lengthy NHL career of over 600 games, he joined the expansion team Buffalo Sabres in 1970–1971, where he appeared in 78 games and scored 16 points. (Rochester Americans.)

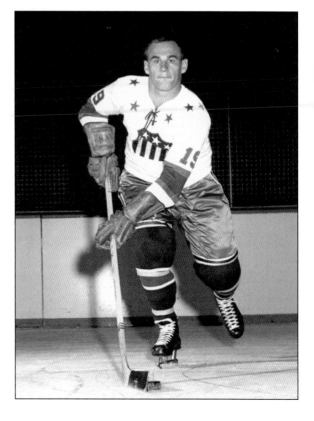

CRAFTY KRAFTCHECK. "One of the smartest players I ever saw," Don Cherry once said in praise of Steve Kraftcheck. A three-time AHL All-Star and two-time Calder Cup winner with the Cleveland Barons before coming to Rochester in 1958, Kraftcheck did not miss a proverbial beat and was selected an all-star three years in a row with the Amerks. In 1959, following a season as the team's third captain, he earned the league's first Eddie Shore Award as the leading defenseman. As a player and coach the following year, he pulled off the impossible series turnaround against his former Cleveland club with Rochester's Miracle Team. A tremendous body checker and an assist machine, Kraftcheck set the league's all-time assist record in 1961 and retired as the best scorer among defensemen with 67 goals and 453 points—a record that held until the 2003–2004 season. He is a member of the Rochester Americans Hall of Fame's class of 1993. (Rochester Americans.)

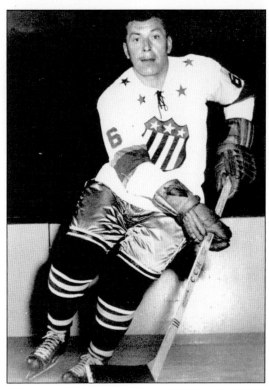

Sibley's wishes the Rochester Americans "a winning season"

STEVE KRAFTCHECK PICKS A CHAMPION SHIRT STYLE

Sibley's University wash and wear oxford cloth

Rochester Americans player-coach Steve Kraftcheck agrees with the majority of our customers for a neat-looking, well-groomed appearance there isn't a shirt that can beat this fine white oxford cloth button down. It's the ideal minimum care shirt to wear "on the road" and at home. Because of its popularity, this is the shirt Sibley's gives free to the Rochester player scoring two goals in a game. It's available at Sibley's Downtown and at Irondequoit, Eastway and Southtown suburban stores. **3.95**.

Hockey tickets are available at our street floor sporting goods department

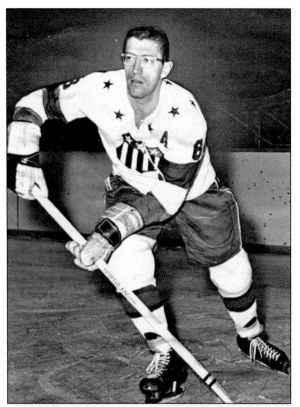

RADAR. The ultimate defenseman, Al Arbour was one of the most admired and respected men to ever play for the Amerks. A four-time first-team AHL All-Star, three-time Stanley Cup winner as a player, and two-time Calder Cup winner with Rochester in 1965 and 1966, Arbour knew what it was to win, and win frequently. He posted 15 goals and 101 points as an Amerk in 320 games from 1962 to 1967. Teammate Don Cherry said "nobody blocked pucks better than Arbour. He gathered them in. He did not let pucks bounce blindly off his body." He also honed his leadership skills in Rochester, first as captain in 1962–1963 and then as Joe Crozier's assistant coach while still playing. His mentorship served him well when he coached the New York Islanders to four straight Stanley Cups from 1980 to 1983. He was an inaugural member of the Rochester Americans Hall of Fame in 1986. (Rochester Americans.)

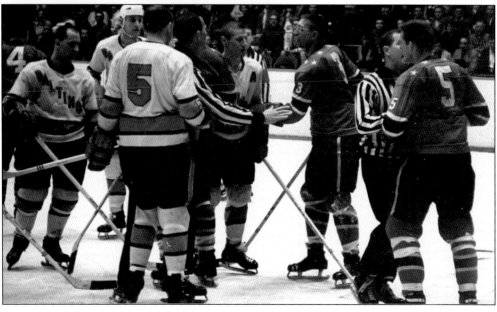

THE SLY ONE. Only Jody Gage, Dick Gamble, and Red Armstrong played more games for Rochester than Darryl Sly, who appeared in 517 Amerk contests from 1960 to 1968 and 1972 to 1974. "Outside of Bobby Orr, Sly had the best skating legs I've ever seen," stated Don Cherry. Sly also amassed 183 points during his 11 seasons of duty in Rochester, appeared in 79 NHL games, and was elected to the Rochester Americans Hall of Fame in the inaugural class with his fellow blue liner Al Arbour in 1986. (Rochester Americans.)

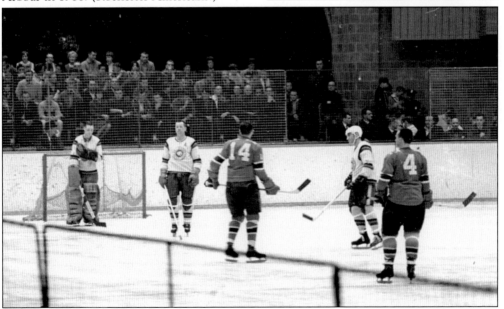

OVER THE LINE? Some consider him a genius; others say he is outrageous. But all agree he is never dull. Canada's television hockey icon and legendary coach Don Cherry played from 1963 to 1969 with the Amerks and again in 1971–1972. He then served as coach and general manager from 1972 to 1974 and helped rescue a proud franchise in its darkest hour. His autobiography is a must-read for those who appreciate a candid view of the game. He was elected to the Rochester Americans Hall of Fame in 1987. (Rochester Americans.)

GENTLE GIANT. Known for his big mitts, Duane Rupp patrolled the Amerks' blue line from 1963 to 1967 and again from 1975 to 1977, serving as coach of the team as well from 1976 to 1979, but he was smart about penalties. He was a key part of two Rochester Calder Cup teams and a two-time AHL All-Star, often paired with Al Arbour. Don Cherry said, "Rupp was a very good positional player who never got rattled. He made things look easy and that is the reason the fans sometimes got on him." Rupp was named to the Rochester Americans Hall of Fame in 1991. (Rochester Americans.)

RUGGEDNESS. The durable Larry Hillman brought NHL championship experience to Rochester that served him well as captain of the franchise's first Calder Cup champions in 1965. A first-team AHL All-Star that season, Don Cherry summed him up as follows: "Hillman could really move the puck and was a great team man. He did not smoke or drink, and that is why he had a 20-year playing career." (Rochester Americans.)

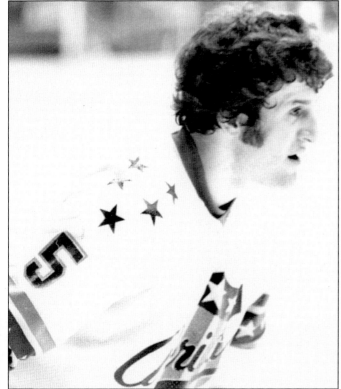

PAGS. Rick Pagnutti wore the red, white, and blue from 1972 to 1976 and ranks as the Amerks' second all-time defensemen in overall scoring with 45 goals and 194 points in 278 games. In one of his best seasons in Rochester, he was named an AHL second-team all-star in 1972–1973. (Joe Giordano.)

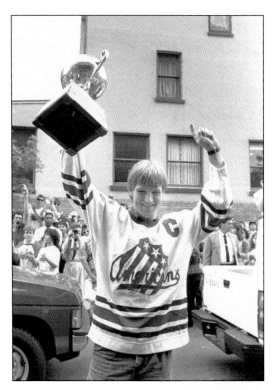

DAVE DOES IT. Although he played over 350 regular-season games with Rochester, Dave Fenyves will be best remembered among the faithful fans for his MVP performance of 3 goals and 15 points in 18 games in the 1987 Calder Cup playoffs that brought the Amerks its fifth franchise Calder Cup. Fenyves was the 2004 selection for the Rochester Americans Hall of Fame. (Rochester Americans.)

DON'T MESS AROUND WITH JIM. Sudbury, Ontario, native Jim Hofford was a solid, scrappy defenseman known for his devastating hip checks who played from 1984 to 1990 with the Americans. He compiled 526 penalty minutes over just two years from 1986 to 1988. A member of the 1987 Calder Cup champions, he is one of only three Amerks in franchise history with more than 1,000 penalty minutes. (Rochester Americans.)

THE OFFENSIVE DEFENSEMAN. Detroit, Michigan's Don McSween was a two-time NCAA Championship All-Tournament selection while with the Michigan State Spartans. He played with Rochester from 1987 to 1992, compiling 45 goals and 215 points during the five-year period, earning him the distinction of the all-time leader in franchise history for scoring among blue liners. (Rochester Americans.)

DIAMOND IN THE RUFF. Future Sabres coach and hard-nosed defenseman Lindy Ruff spent one season with the Amerks in 1991–1992 after a 13-year NHL career with Buffalo and the New York Rangers. He tallied 10 goals and 34 points with 110 penalty minutes in 62 games for Rochester. (Rochester Americans.)

Hooooo-da. Doug Houda, who became assistant coach in Rochester after his retirement in 2003, was known for his willingness to tangle and tussle during his 1999–2003 stint as an Amerks defenseman. He is best known for the 642 penalty minutes he tallied in those four seasons after a 561-game, 1,104-penalty minute career in the NHL. (20 Toe Photo.)

Rory Roars into Town. On October 5, 2001, in front of almost 10,000 fans, 26-year-old Rory Fitzpatrick became the first Rochester native to don an Americans jersey in the franchise's 46-year history. He scored nine goals in 101 games for the Amerks from 2001 to 2003 and appeared with Buffalo in the first regular-season NHL game ever held in Rochester on November 12, 2003, a 2-2 tie in front of a capacity 11,146 fans versus New Jersey. (Rochester Americans; photograph by 20 Toe Photo.)

Seven
ROCKETS' RED GLARE

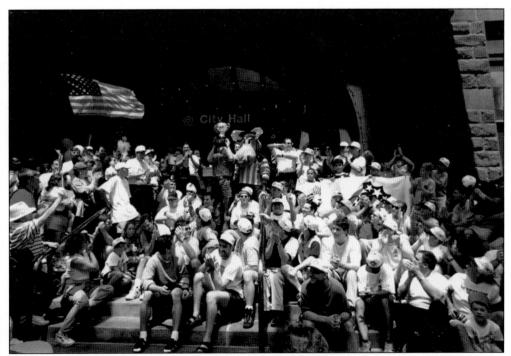

MOOSE ON THE LOOSE. In this 1996 photograph, the Rochester Americans—including their mascot of a quarter-century, the Moose—celebrate their sixth fanchise Calder Cup on the steps of city hall with an exuberant crowd of supporters. (Rochester Americans.)

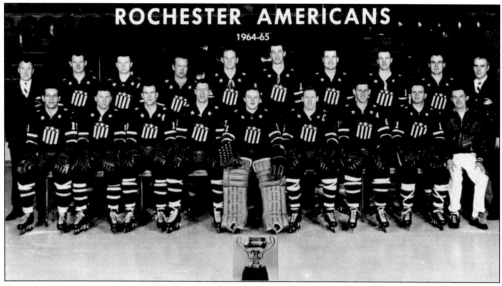

THE 1964–1965 CALDER CUP TEAM. Team members, from left to right, are as follows: (first row) Stan Smrke, Wally Boyer, Gerry Ehman, Al Arbour, Gerry Cheevers, Larry Hillman (captain), Dick Gamble, Les Duff, and Ken Carson (trainer); (second row) Joe Crozier (coach and general manager), Bronco Horvath, Don Cherry, Red Armstrong, Jim Pappin, Ed Litzenberger, Duane Rupp, Billy Harris, Darryl Sly, and Dave Faunce (publicity director). Jim Pappin scored the cup-winning goal. (Rochester Americans.)

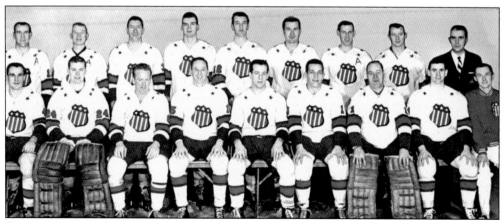

THE 1965–1966 CALDER CUP TEAM. Team members, from left to right, are as follows: (first row) Darryl Sly, Gary Smith, Red Armstrong, Jim Pappin, Larry Jeffrey, Stan Smrke, Bobby Perreault, Mike Walton, and Ken Carson (trainer); (second row) Gerry Ehman, Don Cherry, Al Arbour, Brian Conacher, Ed Litzenberger, Duane Rupp, Dick Gamble, Bronco Horvath, and Dave Faunce (publicity director). Jim Pappin scored his second-straight cup-winning goal. (Rochester Americans.)

THE CROW. Joe Crozier, a 1986 inaugural inductee into the Rochester Americans Hall of Fame, is the second winningest coach in Rochester history and, with his three Calder Cups, the only one to win more than one Calder Cup with the team. He considers the 1965–1966 team the most powerful club of his three championship squads. (Rochester Americans.)

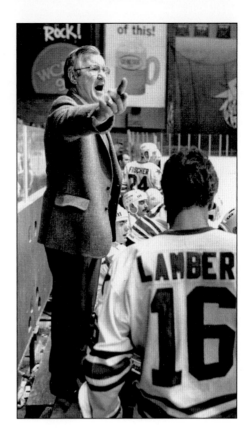

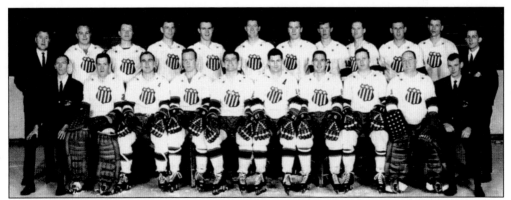

THE 1967–1968 CALDER CUP TEAM. Team members, from left to right, are as follows: (first row) Steve Bartlett (assistant trainer), Carl Wetzel, Darryl Sly, Red Armstrong, Jim McKenny, Bryan Hextall Jr., Bob Barlow, Les Duff, Bobby Perreault, and Ken Carson (trainer); (second row) Joe Crozier (coach and general manager), Don Johns, Don Cherry, Marc Reaume, Andre Champagne, Len Lunde, Bob Cook, Garry Unger, Murray Hall, Dick Gamble, Ted Taylor, and Jim Ball (publicity director). Len Lunde scored the cup-winning goal. (Rochester Americans.)

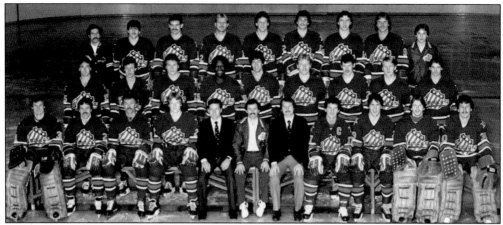

THE 1982–1983 CALDER CUP TEAM. Team members, from left to right, are as follows: (first row) Phil Myre (assistant coach), Gary McAdam, Yvon Lambert, Dave Fenyves, George Bergantz (general manager), Jim Pizzutelli (head trainer), Mike Keenan (coach), Mal Davis (captain), Bob Mongrain, Rick Knickle, and Paul Harrison; (second row) Chris Langevin, Geordie Robertson, Kai Suikkanen, Val James, Jim Wiemer, Steve Dykstra, Ron Fischer, Kari Suoraniemi, and Jere Gillis; (third row) John Cianciotto (stick boy), Jean Francois Sauve, Daniel Naud, Dirk Rueter, Randy Cunneyworth, Lou Crawford, Don Keller, Clint Fehr, and John Allaway (assistant trainer). Val James scored the cup-winning goal. (Rochester Americans; photograph by Colorgraphics.)

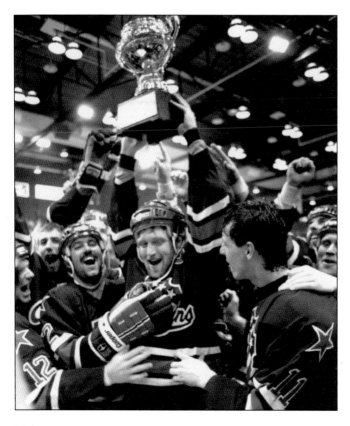

VICTORY CELEBRATION. Captain Dave Fenyves is swarmed by his teammates as he lifts the 1987 Calder Cup. (Rochester Americans.)

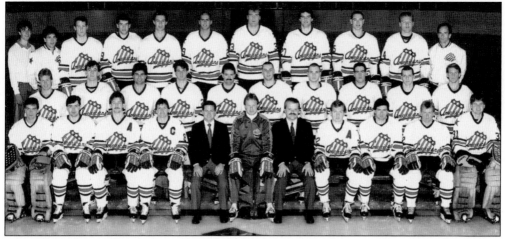

THE 1986–1987 CALDER CUP TEAM. Team members, from left to right, are as follows: (first row) Mike Craig, Claude Verret, Mark Ferner, Don Lever (captain), George Bergantz (general manager), John Van Boxmeer (coach), Don Stevens (broadcaster), Jay Fraser, Jody Gage, Mikael Andersson, and Daren Puppa; (second row) Jim Jackson, Jim Hofford, Bob Halkidis, Richard Hajdu, Richie Dunn, Ray Sheppard, Paul Brydges, Bob Logan, Benoit Hogue, and Doug Smith; (third row) J. C. Ihrig (stick boy), Jeff Croop (assistant trainer), Shawn Anderson, Doug Trapp, Jack Brownschidle, James Gasseau, Wayne Van Dorp, Joe Reekie, Jeff Parker, Steve Dykstra, and Kent Weisbeck (trainer). Gates Orlando (not pictured) scored the cup-winning goal. (Rochester Americans.)

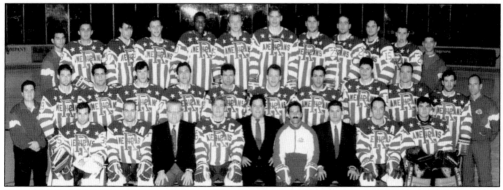

THE 1995–1996 CALDER CUP TEAM. Team members, from left to right, are as follows: (first row) Robb Stauber, Terry Hollinger, Don Stevens (broadcaster), Dane Jackson (captain), Steve Donner (president and CEO), John Tortorella (coach), Joe Baumann (general manager), Jamie Leach, and Steve Shields; (second row) Pete Rogers (equipment manager), Dixon Ward, Dean Melanson, Scott Pearson, Dan Frawley, Jody Gage, Scott Metcalfe, Serge Roberge, Grant Jennings, Jay Mazur, Craig Charron, and Kent Weisbeck (trainer); (third row) Paul Camelio (equipment assistant), Mikhail Volkov, Barrie Moore, Sergei Klimentiev, Rumun Ndur, Ladislav Karabin, Mike Wilson, David Cooper, Bob Westerby, Shayne Wright, Scott Nichol, and Jeff Camelio (equipment assistant). Terry Hollinger scored the cup-winning goal. (Rochester Americans; photograph by Colorgraphics.)

OUR FLAG IS STILL THERE. The ecstatic crowd is on the old stage of the War Memorial at the end of the 2-1 Game 7 victory over the Portland Pirates that gave the Rochester Americans their sixth Calder Cup. To all who have made the last half-century of this franchise's success so thrilling and enjoyable, we say thanks, Amerks. (Rochester Americans.)